IMAGES
of America

CHARLTON

12/17/01

To cousin Bev. with
warmest regards from

Bill Hultgren

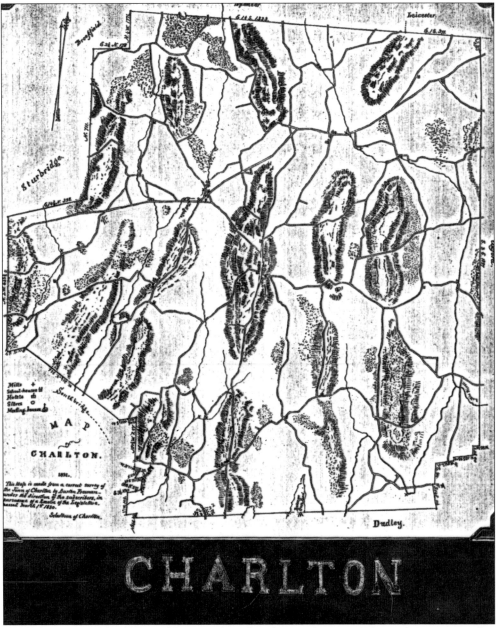

CHARLTON

The Commonwealth of Massachusetts required each township in 1830 to submit a map of its town. The town of Charlton is depicted on this 1831 map indicating special points of interest. The mills, schoolhouses, hotels, stores, and meetinghouses are shown. Burton Freeman, the surveyor, felt that the remaining woodlands, which, by this time, had been cleared for farming and pasturing, were noteworthy enough to put on the map.

IMAGES
of America

CHARLTON

William O. Hultgren
for the Charlton Historical Society

ARCADIA

First printed in 2001.

Published by Arcadia Publishing,
an imprint of Tempus Publishing, Inc.
2A Cumberland Street
Charleston, SC 29401

Printed in Great Britain.

Library of Congress Catalog Card Number: 2001092556

For all general information contact Arcadia Publishing at:
Telephone 843-853-2070
Fax 843-853-0044
E-Mail sales@arcadiapublishing.com

For customer service and orders:
Toll-Free 1-888-313-2665

Visit us on the internet at http://www.arcadiapublishing.com

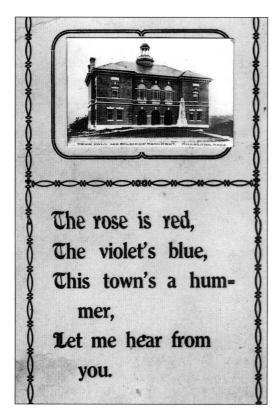

The William Henry Dexter Memorial Town Hall is featured on this 1912 postcard with its little jingle.

CONTENTS

ACKNOWLEDGMENTS

In the past few years, the Charlton Historical Society has sponsored two pictorial history books drawing from the society's archives and the private collections of others interested in the history of Charlton.

Many additional photographs have been collected since the publication of the last book, giving us a wider view of the scenes that make up the history of a community.

In bringing this pictorial history to the public, I wish to thank many people who have given me their assistance in collecting, culling, and sorting the many photographs and captions.

Especially, I wish to thank Joyce Stewart and Donald Weinhardt for their help in selecting the photographs and typing captions. Thank you to Kevinetta O'Brien for her hours of organizing and copying, to Judy Maskell for her emergency typing, and my wife, Marilyn, for all her help in many areas.

The following have graciously loaned or given me or the Charlton Historical Society the images that are included in this publication: Quentin Kuehl, Richard Green, Melvin Baker, Robert Baker, Gilbert Russell, John Woodbury, Frank Morrill, R. Reed Grimwade, Southbridge News, Nellie Putnam, Carol Pike Fisher, Dorothy Lund, Old Sturbridge Village, Dorothy Truesdell, Lillian Hemenway heirs, Robert S. Ewing, Mildred Mahan estate, Daniel H. Tucker, Warren Gale, Willard McCracken Jr., Wilbur H. Johnson heirs, Mildred Gevry, Hazel Johnson, Steven Clark, C.W. Lawrence, Bernard Anderson, Charles Vizard, Alva Hunt, Donald Beal, Dorothy Woodbury, Jesse Williams, Frank Hammond, Helen Cheney, Fred Maass, Ruth Duhamel, Fredna Clark, Eleanor Pellissier, Robert Westberg, Lucy Stevens, Barbara Dunn, Kevinetta O'Brien, Alberta Putnam, Marion McIntire, Rhoda Josephson, Wilfred Casey, John McKinstry, Marguerite Stearns, Sherman Eastman, Society for the Preservation of New England Antiquities, and others whose names are unknown.

—William O. Hultgren
Charlton, Massachusetts
2001

INTRODUCTION

Settlement began in the area that became Charlton as early as 1720. Many of the first settlers took up "farms" of 100 acres offered for sale by absentee owners or the colony of Massachusetts Bay. Most of these lands were in the township of Oxford, settled early by French Huguenots. West of the village line of Oxford were thousands of acres of vacant land. When these lands came on the market, many families from the north shore towns of Salem and Danvers came to settle on these lands. North of the Oxford lands was a long triangle-shaped piece of land called the Gore—about 6,000 acres belonging to no town. Gore lands were some of the earliest areas to be settled, but, since they belonged to no town, no deed of sale could be registered in any county.

These settlers, having a geographical bond, began to ask that a new town be incorporated from the west Oxford lands and those of the adjacent Gore. The request was twice rejected. On the third try, success was granted to the west Oxford people in 1755, and the Gore joined two years later.

Rapid settlement began after the end of the Revolution. State-confiscated Tory lands were taken up and, each year, more land was put beneath the plow. By 1840, so little uncleared land remained that the map surveyor included these areas when he drew his map.

Farms flourished. By the early 1800s, Charlton was a leading agricultural town in the county. Farming was always a dominant occupation of Charltonians, but a multitude of small brooks encouraged the mechanic to build dams and set up mills.

As early as 1790, the area alongside Cady Brook was called the "City" because of its many small mills. In the east part of Charlton, along the Little River, another concentration of mills gave it the name Millward.

The arrival of the trains in 1838 ushered in another phase of Charlton's growth. Now farmers could increase their dairy herds and find a market for the fresh milk in the cities of eastern Massachusetts. Farms with large herds prospered. Several milk cars left Charlton Depot daily. The village of Charlton Depot developed to supply the needs of the railroad.

In the 20th century, smaller farms began to disappear, the fields growing up to woods. A lumber industry developed, harvesting these woodlots. A number of sawmills operated in all sections of town.

After World War II, farming further declined and people began to drive to jobs outside the community. By the close of the 20th century, the last of the dairy farms were sold and the new developments of suburban housing took their place.

The last train stopped at the depot in 1960. The Massachusetts Turnpike was built through Charlton in 1956, giving quick access to areas east and west.

Located equally distant from Boston, Springfield, Providence, and Hartford, Charlton has been "found" as a bedroom community. The rural character is strongly supported. However, with the population nearing 13,000, that character, which many have moved to Charlton to enjoy, now feels the pressure of development.

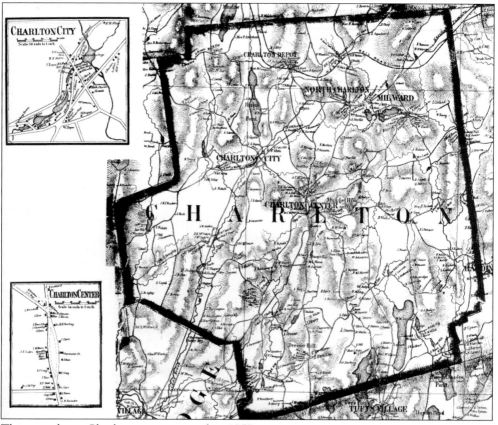

This map shows Charlton as it appeared in 1857.

One

INSTITUTIONS AND
CIVIC SUBJECTS

This view of the Charlton High School and the adjacent Universalist church appears on a 1905 postcard. The District No. 1 school was built in 1888 to provide two rooms for students in grades one through eight. The second floor was used for municipal purposes. The Universalist church was erected in the 1820s after the doctrinal split with the Congregationalists over universal salvation. The large church built earlier on the Charlton Common proved too large for the Universalists. The old church was torn down, and this church was built on the east side of the common. The Congregationalists also built a new church south of the common. The school was destroyed by fire in 1922, along with the church. In its stead, a new Charlton High School was built.

The Patrons of Husbandry, or Grangers, built this hall on Main Street in 1891 to promote the understanding, advancement, and development of the rural population while providing a much needed social environment.

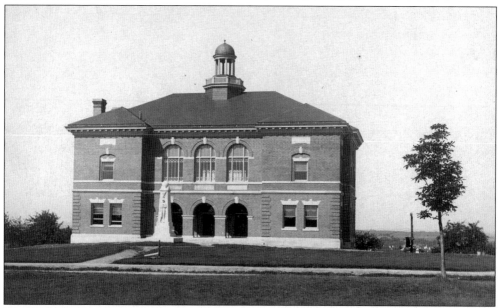

The William Henry Dexter Memorial Town Hall was built in 1905. Charlton had not had a town hall before this building was built by native son William H. Dexter, who presented this structure to the town as a hall and library. Earlier, the basement of the Universalist church had housed town offices and the local lockup, while the upper floor was used for religious purposes in true meetinghouse fashion. Dexter first provided the Civil War Monument in the photograph in 1903. Two years later, he had the town hall building constructed and furnished. The site is the former Belleview Hotel lot.

This 1880 photograph of the Charlton Alms House shows the new house and barns built to replace the old Ebenezer Davis house of 1740. The poor farm closed in 1961. Ernest Hosington and his wife, Hazel, were the last overseers from 1954 to the house's closing.

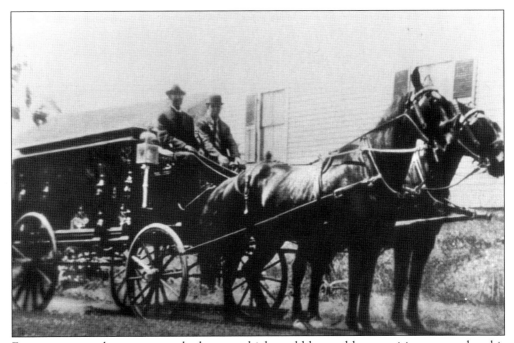

For many years, the town owned a hearse, which could be used by any citizen to conduct his remains to the cemetery. The man holding the reins is Lewis McIntyre, the town undertaker.

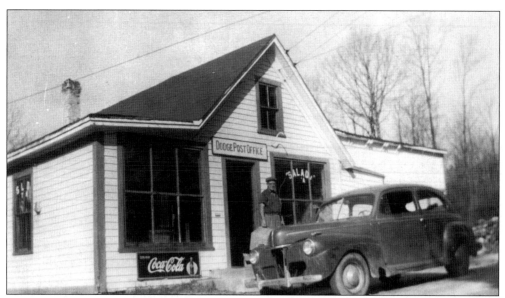

The Dodge Post Office and Axel Olson's Store are shown in 1954 with rural free delivery (RFD) mail carrier Harry Clark on the last day of the mail route. The Dodge postal service was then transferred to Charlton Center.

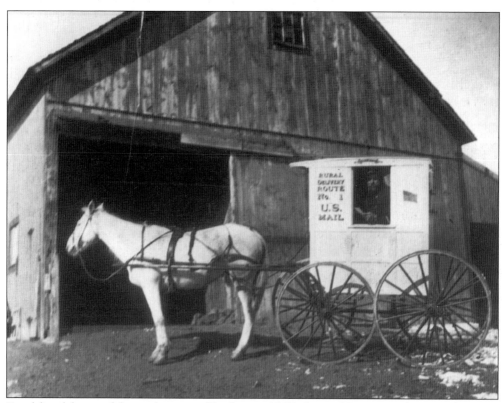

Rural free delivery of the mail came to Charlton in 1897. George Norcross is shown in this 1900 photograph with his horse and wagon.

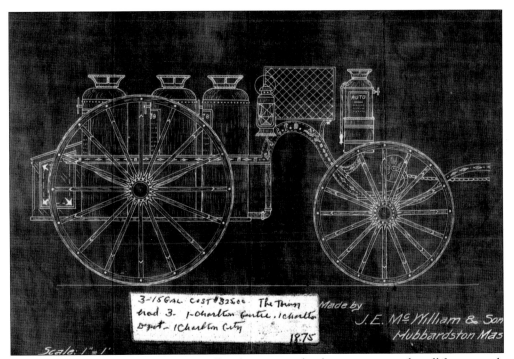

In 1875, Charlton acquired three 15-gallon fire engines for the suppression of small fires in each of three villages—Charlton Center, Charlton City, and Charlton Depot—at a cost of $325.

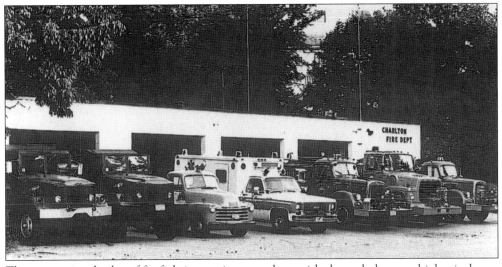

This impressive display of firefighting equipment, along with the ambulance vehicles, is shown outside the Charlton City fire barn in 1960.

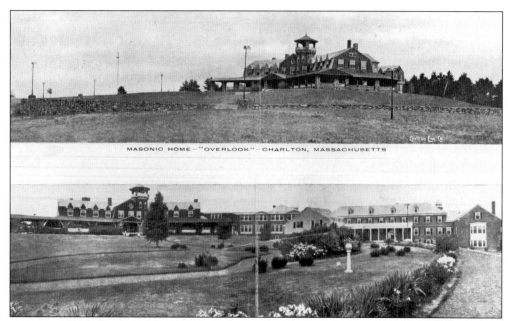

MASONIC HOME—"OVERLOOK"—CHARLTON, MASSACHUSETTS

Built by the Worcester & Southbridge Street Railway Company, the 1903 Overlook Hotel was short lived. Embezzlement by the general manager forced closing of the hotel and put the trolley line into receivership. After a few years, the hotel was purchased by the Grand Lodge of Massachusetts in 1908 for a retirement home for Masons and their spouses. The lower view shows two additions, Williams and Davenport.

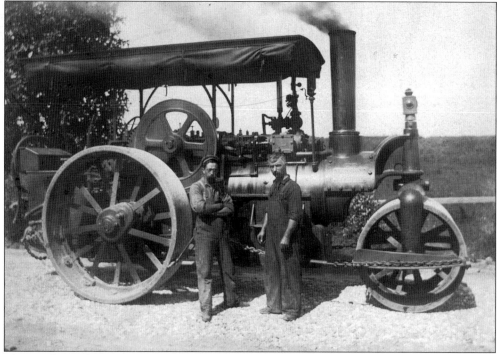

This is the early steam-powered roller used by the Charlton Highway Department at the beginning of the 20th century. Operator Harold Culver (left) poses with an unidentified assistant.

14

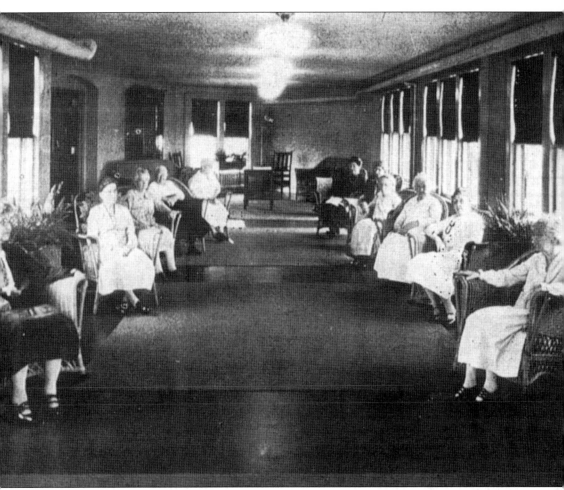

The interior view of the Masonic Home Ladies' Solarium is captured in this 1930s photograph. When the additions were added to the Masonic Home's original Overlook Hotel building in 1927, a solarium was added for the use of the residents.

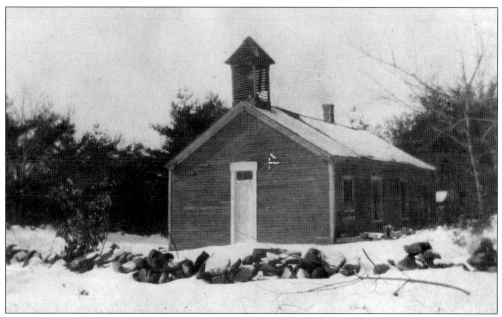

The Wayside Advent Christian Church on Haggerty Road is shown here before it was remodeled in the 1930s.

Rev. Calvin Reinhardt, pastor of the Wayside Advent Christian Church, poses with his congregation and Sunday school members in this 1931 Children's Day photograph.

The Wayside Advent Christian Church is located on Haggerty Road in South Charlton. It is Charlton's oldest church structure. This church is an outgrowth of the Millenniest movement of the mid-1800s. The name Wayside Advent Christian Church was adopted at the suggestion of Rev. Stanley Reinhardt, who began his pastorate in 1923. It was during his pastorate that the church was remodeled. Today, it is the Charlton Bible Fellowship.

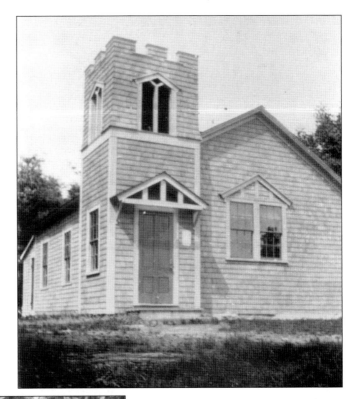

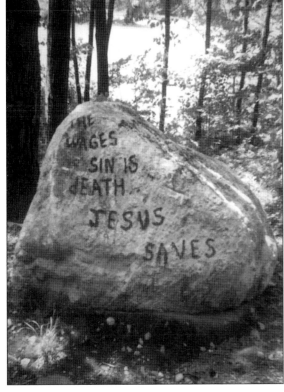

The Gospel Stone, a painted boulder, was located on the west side of Partridge Hill Road next to the South Charlton Reservoir. It was painted by Irwin Stevens. This 1972 photograph shows its current message.

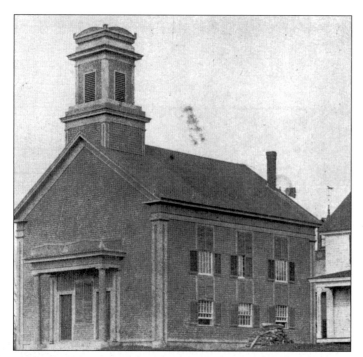

The Charlton City Methodist Episcopal Church was organized early in Charlton's history. By 1792, the Charlton Methodist Christians were organized into an official Methodist society, meeting in the home of Elijah Batchelder in the far southwest corner of town. After meeting in various halls, the Methodists built this church on the southeast corner of Stafford Street and Brookfield Road in 1854, in front of the home of Edward Akers. The church burned in 1890. A new church was rebuilt on the same site, dedicated in 1896.

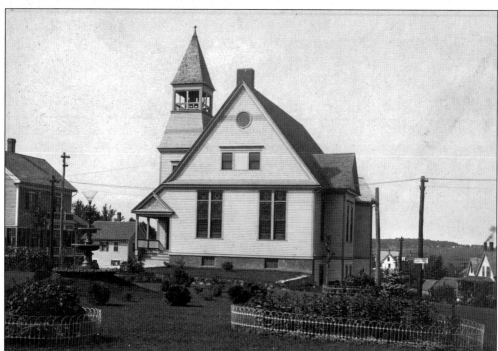

Church trustee and mill owner Edward Akers found that the proximity of the new Methodist church to his home was damaging his property. He proposed to pay for moving the church across Brookfield Road and to put a basement beneath it, complete with kitchen, dining room, and ladies' parlor. This caused a great deal of controversy in the church, but the offer was taken and the church moved in 1906 to a new location, shown in this 1920 photograph.

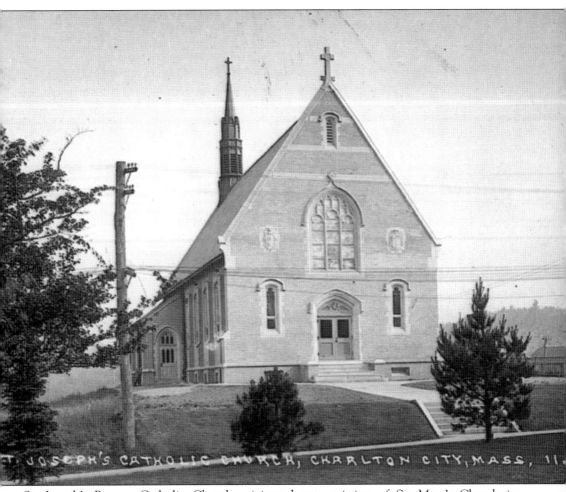

ST JOSEPH'S CATHOLIC CHURCH, CHARLTON CITY, MASS, 11.

St. Joseph's Roman Catholic Church originated as a mission of St. Mary's Church in Southbridge. Masses were first read in a private home at Charlton Depot and, in 1887, the mission church, named Sacred Heart, met in a building on the City-Depot Road opposite the Spring Brook mill. In 1904, a new church called St. Joseph's was dedicated on the Worcester Road site. This wooden structure was destroyed by fire in 1923, and a new brick church was built on the same site. St. Joseph's remained at this location until its new, large church on H. Putnam Road extension was dedicated in 2001.

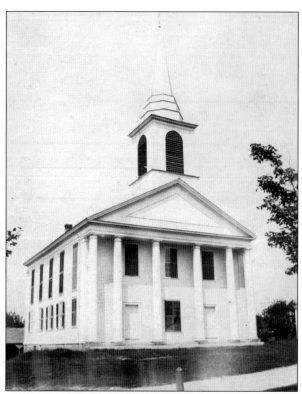

Elias Carter designed the Calvinistic Congregational Church for the society, which split from the Universalists in 1824 on land donated by Gen. Salem Town. Originally, it was designed with the pews facing the entry door—a situation that was changed in the remodeling of the church in 1856. The church was destroyed by fire on Christmas Day 1939. The fire in the adjacent McInitire house spread to the church, leveling both.

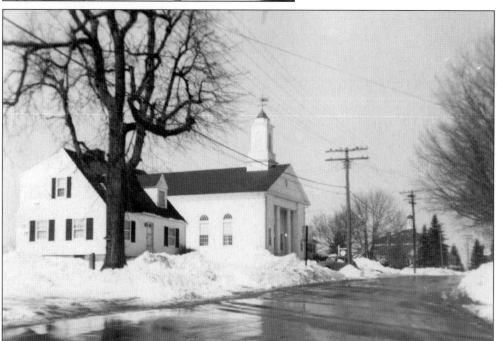

The 1941 Federated Church of Charlton replaced the fire-destroyed 1826 meetinghouse of the Congregational and Universalist societies, which had federated in 1922. The new church was built on the same Main Street site. The house on the left is the new parsonage, built in 1950.

Two

VIEWS, LANDSCAPES, AND STRUCTURES

In 1901, a group of interested citizens in the eastern part of Charlton known as Dodge village organized the Church of Christ in Charlton and erected a chapel building on Hammond Hill Road. After a short time, attendance dwindled. By 1905, many members transferred to other local churches and this church society was dissolved. In 1916, the chapel was acquired by the Helping Hand Society, made up of women of all faiths. They have added a wing to the chapel, which is used for annual meetings and dinners, as well as visiting religious leaders.

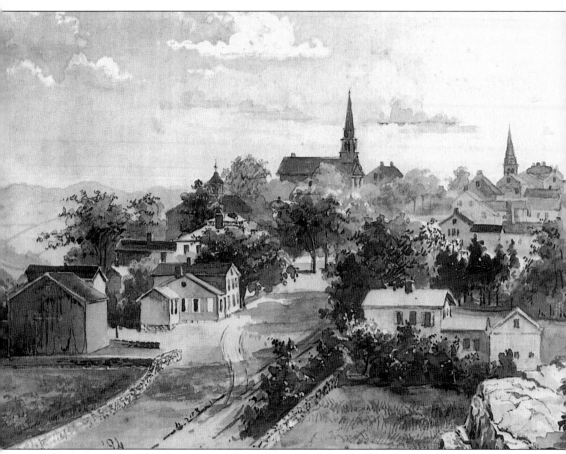

This is a view of Charlton Center from the north. John C. Woodbury painted this watercolor with chalk highlights in 1894. On the left are the old Salem Town barns and 1775 house. Town's 1796 mansion house with the monitor roof is just beyond. The cupola of the Wakefield barn rises above the mansion house. The tall spire of the Universalist church is in the center. To the right of the Universalist church, the two chimneys of the Dr. Phillips's house can be seen. In the right foreground is the Dr. Taft house, taken down in the 1960s. Above the Dr. Taft house, in a row, are the Rev. Preble place, the McIntire house, and the Moore house. The Calvinistic Congregational spire is in the distance.

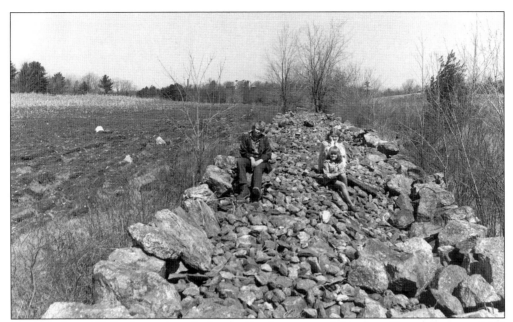

Dr. Fay's Great Wall is located on Burligame Road just west of Charlton Center. Between 1823 and 1840, this wall—16.5 feet wide, 6 feet high (plus 4 feet underground), and more than 660 feet long—was built by Dr. Fay's patients who could not pay their bills. This rocky piece of ground on Dr. Fay's farm provided the material for the wall, which he claimed was "pig-tight, bull-strong and horse high." Eric, Linnea, and Shelley Hultgren are seated on the wall.

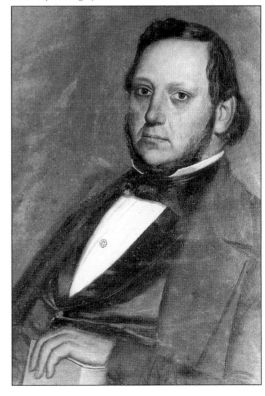

Dr. Charles Fay was a longtime popular physician in Charlton. He lived on Burlingame Road just west of Charlton Common. His land extended westward into the valley, where his indigent patients worked off their debt by clearing stones from his field and building the wall shown in the previous picture.

23

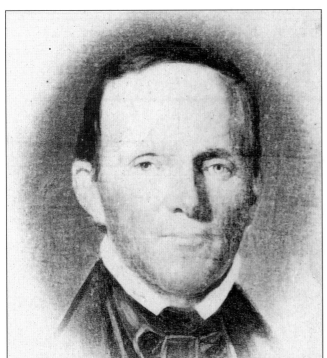

Maj. John Spurr as a youth participated in the famous Boston Tea Party. He later moved to Charlton to oversee his father-in-law's, John Dunbar, extensive holdings. He built a house in 1798, which is still standing on the Charlton Common. Spurr became the most influential leader of the liberal element in Charlton politics. The Spurr and Towne families most often stood on opposite ends of the political and religious spectrum. His life ended in 1816.

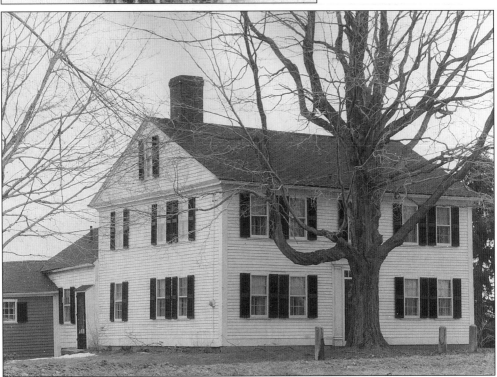

The John Spurr House, at 27 Main Street, was the home of John Spurr, youngest participant in the Boston Tea Party. Spurr moved to Charlton to oversee his father-in-law's extensive land holdings. The small house on the site was enlarged in 1798 into a two-story center-hall house.

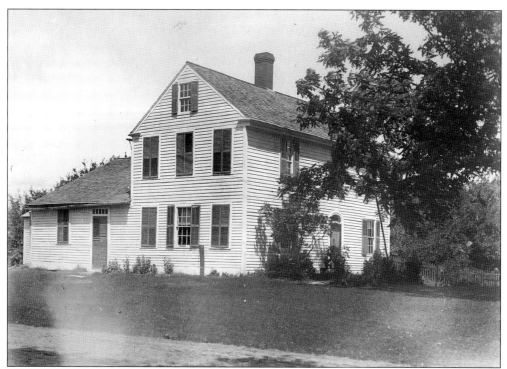

Salem Towne's original 1775 house at 57 North Main Street was extensively remodeled in 1912 by Carlos Bond.

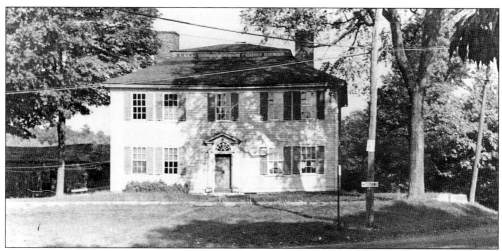

The Salem Town(e) Mansion House was built in 1797 by Salem Town Sr. on the occasion of his third marriage. The house was purchased by Old Sturbridge Village (OSV), cut apart, and moved to Sturbridge, where it was reerected at the head of the OSV common. The barns remained at the site for many years, housing the Stevenses' dairy herd. The house was located at the intersection of North Main Street and Old Worcester Road.

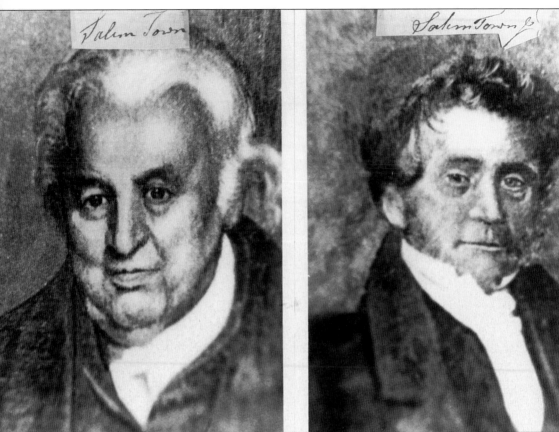

Shown are Salem Town Sr. (1746–1825) and Salem Town Jr. (1780–1872) in portraits by Francis Alexander. The Towns were the leading family in early Charlton. Salem Town Sr. moved from Oxford and built a house at the north end of Charlton Common in 1775. For his third wife, he built the adjacent "mansion house." This house was moved to Old Sturbridge Village in 1953. It is open to visitors as a country gentleman's seat. Salem Town Jr. was heir to his father's extensive holdings. He increased his wealth through mortgage lending and speculation in lands in Maine.

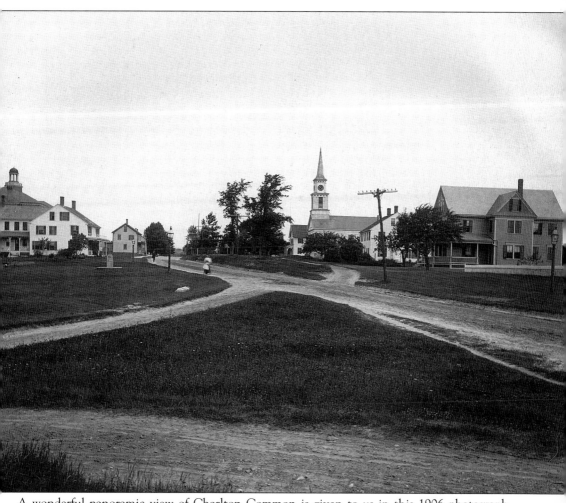

A wonderful panoramic view of Charlton Common is given to us in this 1906 photograph. From left to right are the old Weld Tavern, the new Charlton Town Hall, Knight's store and post office, the District No. 1 school and high school, the Universalist church, the Comins house, and C. Knight's house.

Wallace Nutting—the early-20th-century preacher-turned-photographer of early American buildings and rural scenes—took this 1913 photograph of Rider Tavern. Nutting, whose favorite photographs always pictured apple trees in bloom, caught this view in May. Artistic license allowed him to add a large center chimney to the building. The east barn complex (now gone) is clearly shown. The north militia training field is on the right.

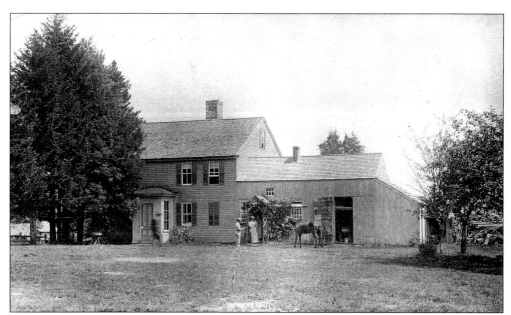

The Ebezener Hammond House, located on Gould Road opposite Buteau Road, was built by Ebenezer Hammond after his purchase of the land in 1739. This photograph is dated 1885. A drop hammer forge was located across the road from the house. It produced nails for local use in the early years of the 19th century. Hammond lived here until the 1930s, when it was bought at a tax auction after the death of Fordyce Hammond.

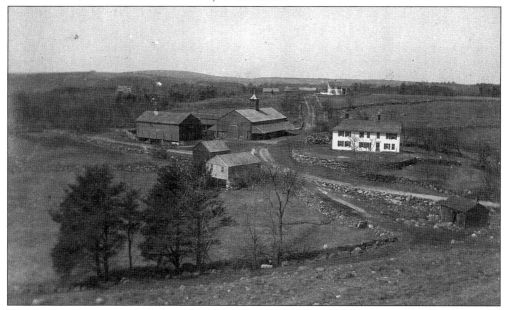

Thirteen generations of Tuckers lived on this 1730s lot of 300 acres. The house in the photograph was originally constructed as a one-story Cape house. The roof was raised and an ell added about the time of the opening of the Worcester and Stafford Turnpike past the house in 1806. For a time, the Tuckers were licensed to serve liquor to refresh the patrons of the stagecoaches, which regularly stopped. When the place was sold out of the family in 1990, the Tuckers were the last of the original families to remain upon their land.

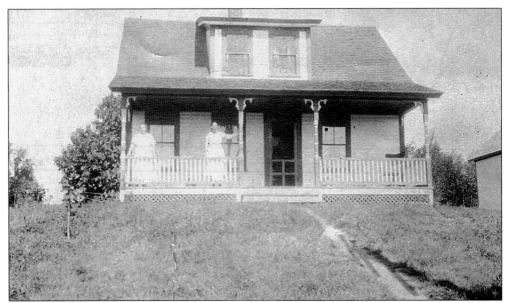

A few bungalows were built in Charlton in the early 1900s, when this style was at its height. Shown in this 1915 photograph is the home of Ada and Alexander Ballard on Worcester Road at Richardson's Corner.

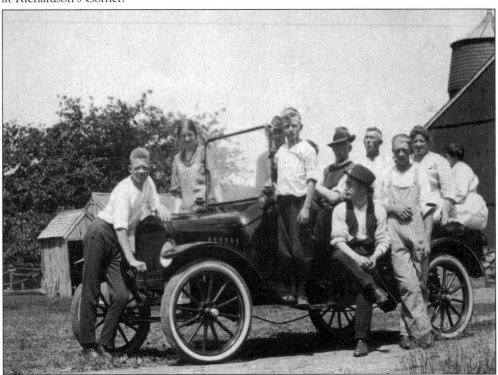

This is a gathering on Brookfield Road at Meadowbrook Farm, Emil Johnson's home in 1923. The photograph shows Johnson with his first automobile. From left to right are Ernest Johnson (at the crank), Alice Quaforth, Walter Johnson, ? Quaforth, William Gustafson, Emil Johnson, Herbert Johnson, Ida Johnson, ? Gustafson, and an unidentified woman.

Guy and Sarah Prindle stand in front of their home atop Prindle Hill in this 1894 view. Prindle, for a time, operated a grocery store in Charlton City, made chocolate, and published early postcard views of Charlton.

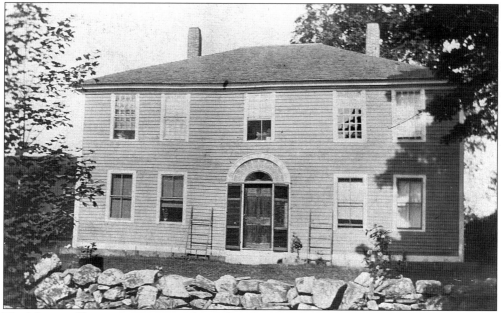

The Merriam House, now gone, was located on the westerly side of the discontinued Curtis Hill Road. The house was built by David Ward in 1818 with lumber from the trees that blew down in the 1815 hurricane. In 1927, this building was destroyed by a fire, started by a hotbox on a train located on the nearby tracks.

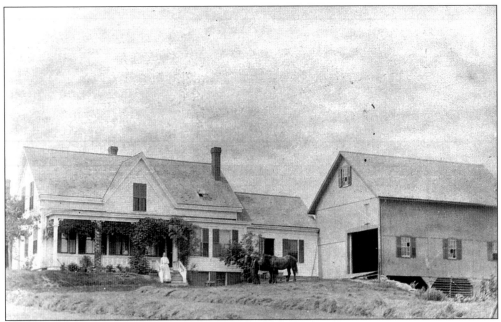

Attorney Herbert Davidson, Charlton town counsel, long lived in this house on Curtis Hill Road. His stepdaughter Marie Sibley lived there until her death. Peter Manzi now owns the property. The house was built by E.S. Southwick *c.* 1869. He was the owner of the Southwick & Lamb Boot and Shoe Shop.

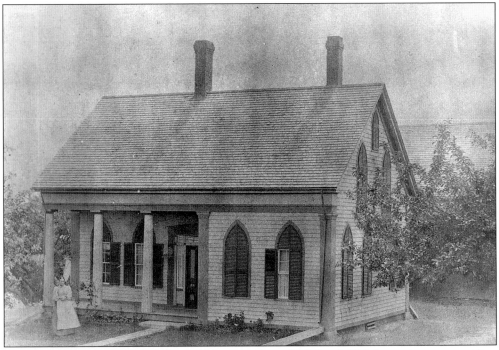

Seen in this view is the Lyman Lamb House, on Curtis Hill Road. This house is an outstanding example of the Gothic Revival style. The lady in the photograph is believed to be Mrs. Weston, who ran a boardinghouse here.

Cady Brook Valley and Southbridge Road is seen here from Union Cemetery in 1910. In this photograph, the Worcester & Southbridge Street Railway trolley car is entering Southbridge Road from its cross-country right-of-way. In the distance is the Akers & Taylor mill on Picker Pond. The mill later burned, and the dam was broken in the high waters of 1936.

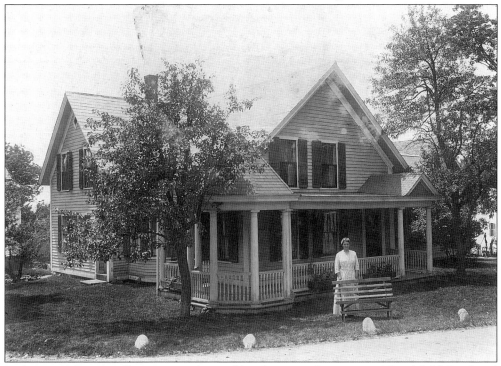

Katherine Adams Bradley poses in front of her home at the corner of Brookfield Road and Stafford Street in this 1912 photograph.

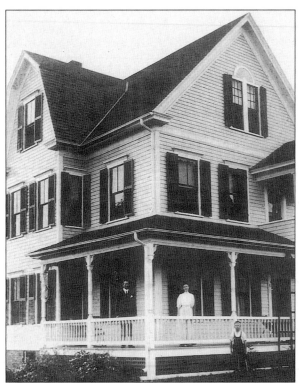

Charlton has but one two-decker home and one three-decker home. This two-family house—designed by Charlton's first architect, Gordon Pike—is on Stafford Street in Charlton City. In later years, it was used for the adjacent Methodist church's Sunday school. It is now a private home.

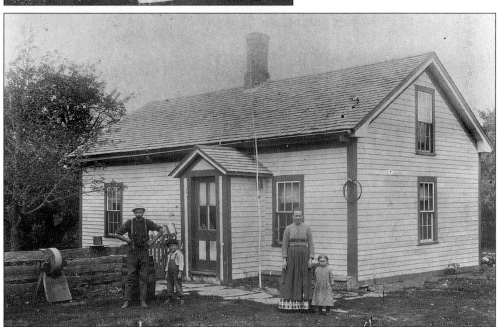

Shown in this 1894 view is the Bracket place on Sturbridge Road. From left to right are Reuben Alvin Bracket, son Reuben Alfred, wife Ellen Stevens Bracket, and daughter Nellie Bracket. When Route 20 (Sturbridge Road) was built in 1928, the house stood close to the road. The Zagicki family purchased the property, moved the house north to its present location, and remodeled it into a two-story house.

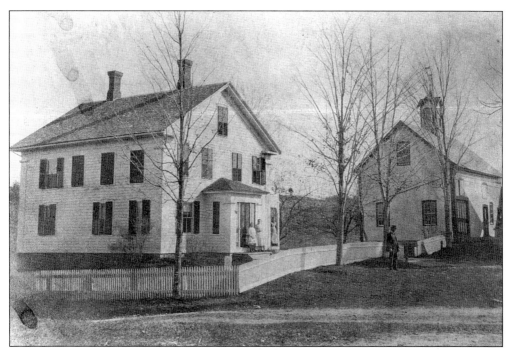

The William Stevens House is shown in 1870. This house, at the corner of Brookfield Road and Stafford Street, was owned for many years by Edward Akers, partner in the manufacturing firm of Akers & Taylor. It has descended in the Taylor family, who today owns the property. Before 1904, the Methodist church stood in the lot to the right of the fence. Akers paid for moving the church across the street, allowing him a place for an expanded yard.

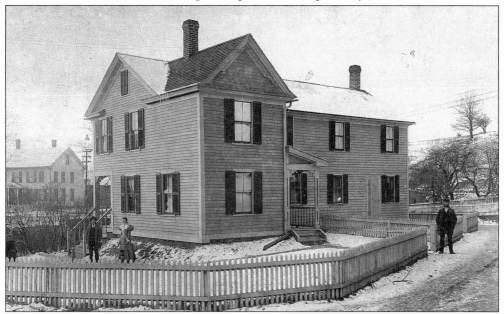

Pictured is the James Hayes house, located on South Sturbridge Road in Charlton City. Severely damaged in the flood of 1955, the house was acquired by the town and removed from the property.

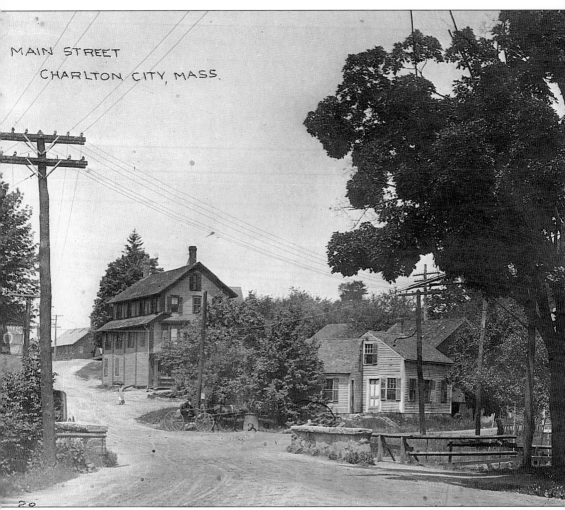

This 1905 postcard view of Main Street in Charlton City is recognized as today's Brookfield Road where it crosses Cady Brook. The J.A. Hayes blacksmith shop is on the extreme left. In the distance up Brookfield Road is the Prouty Wire Shop. In the center is the Clarence Mann store and the Charlton City post office. Jim Hayes's house is next to the right. A thirsty horse enjoys a drink from the trough just beyond the bridge.

Three
AGRICULTURE

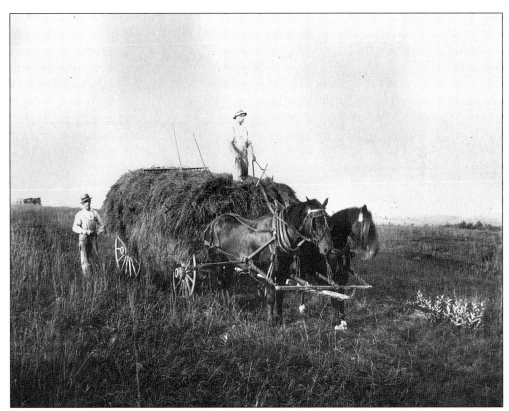

The summit of Muggett Hill, where today's Bay Path Regional Vocational Technical High School is located, was once a vast hayfield. This *c.* 1900 photograph shows a load of hay headed for the M.D. Woodbury barn on the slope of Muggett Hill.

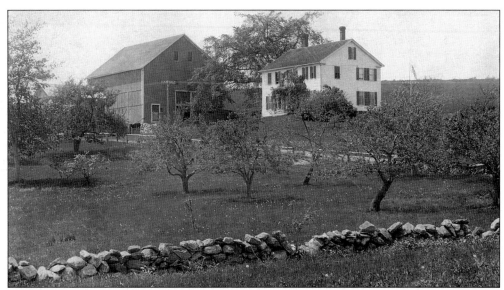

Mashamurket Farm of Moses D. Woodbury is shown in this 1897 photograph. The Nipmuck name of the high hill has evolved into today's Muggett Hill. The farm was purchased by Jasper Eastman, who planted an apple orchard there. Eastman sold the farm to the Southern Worcester Regional Vocational High School. The present Bay Path Vocational Technical High School is built atop Muggett Hill. The house burned in the 1960s.

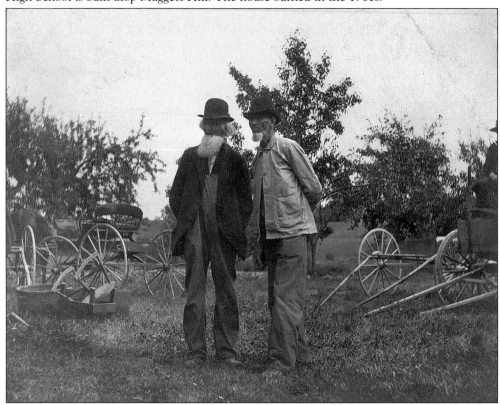

Two elderly gentlemen are in the young orchard of Muggett Hill farm in this 1901 photograph.

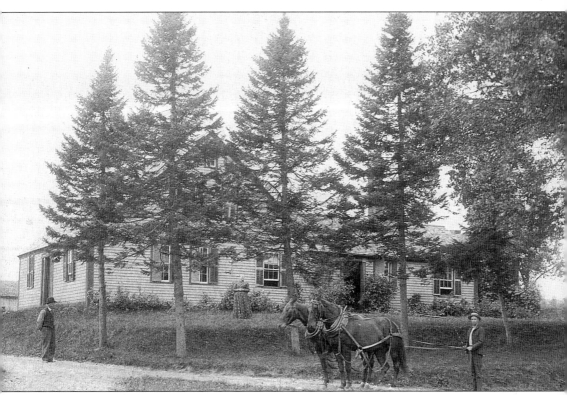

Edwin Phillips stands proudly with his team in front of the Phillips farmhouse on Harrington Road. His parents, Curtis and Lucy Dodge, moved to this house upon their marriage in 1828. When Edwin Phillips acquired the property, he moved the old house and built a new house on the spot.

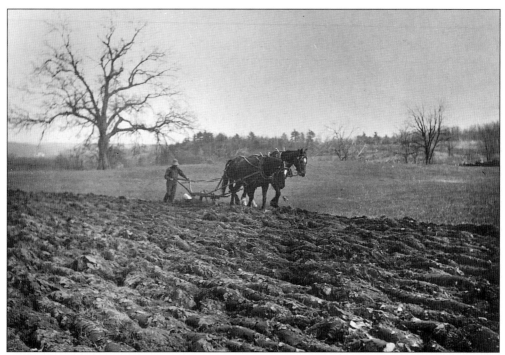

A plowman breaks the spring sod of the field on M.D. Woodbury's Muggett Hill farm. John Woodbury, the engraver, is said to have used this view in designing the Charlton town seal.

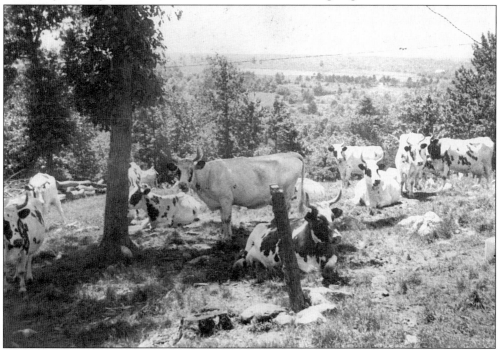

Photographer C.E. Lawrence captured this bucolic scene of a herd of Ayshire cows in the Masonic Home pasture. The caption on the rear of the photograph reads, "Taken at Charlton, Mass. June 6, 1944 2:00 P.M."

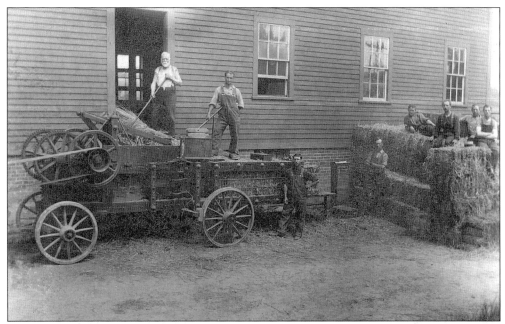

George C. Prouty, standing in the doorway, is baling hay at his mill on Brookfield Road, Charlton City, assisted by three Steadman brothers. Before portable baling machines came into use, hay was brought to the stationary machines.

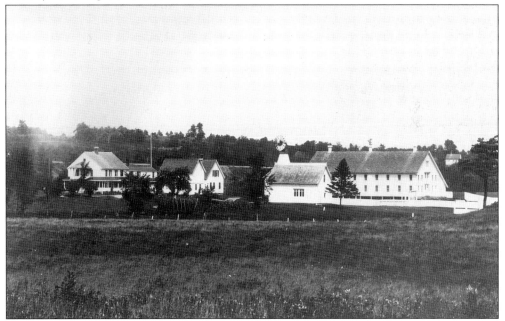

H.I. Gould's Little Valley Farm is seen here in 1900. Paul W. Wheelock built the old house shown on the left by 1740. Herbert I. Gould, local entrepreneur and manufacturer, acquired the property in the late 1800s and expanded the complex. Gould, to facilitate his travel to his shop and store in Charlton Depot, had Gould Road cut through his land. Later owner Hamilton Lincoln planted extensive orchards on the property and gave it a new name, Wee Laddie Farm, by which it is known today.

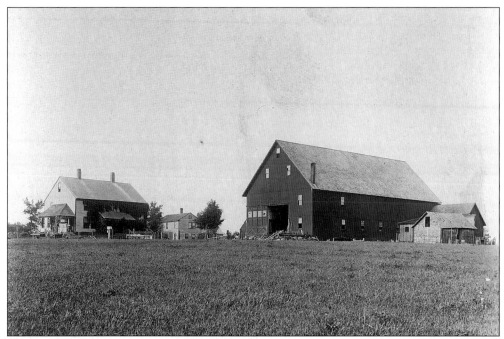

This *c.* 1900 photograph shows Dresser Hill Farm when it was owned by Darius W. Baker. The main house was built by Moses Dresser in 1801 at the junction of Dresser Hill and Schoolhouse No. 6 Roads. Earlier, the house had a long ell, which was the meeting place of the Royal Arch Chapter of King Solomon Lodge of Freemasons and also for services of the Methodist church. The barn in the photograph was burned in 1912 and rebuilt. Dresser Hill Farm was the last operating dairy farm in Charlton when it ceased operations in 2000.

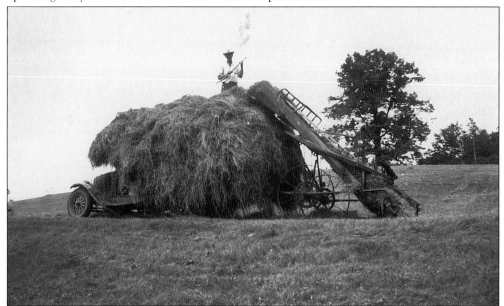

Summertime brought hay time. This old Ford was used as a tractor to haul the hay loader on the Johnsons' Meadowbrook Farm, on Brookfield Road. Walter Johnson is receiving the hay and distributing it for a balanced load in this 1941 snapshot.

Meadowbrook Farm was bought by Emil Johnson in 1911 from the Adams family. Johnson began a milk route, selling unbottled milk. The milk was poured from an eight-ounce can into the customer's container. It cost 4¢ a quart. In 1917, Johnson began selling milk in glass bottles. This 1920 photograph shows him standing next to his delivery wagon with a rack of dairy products.

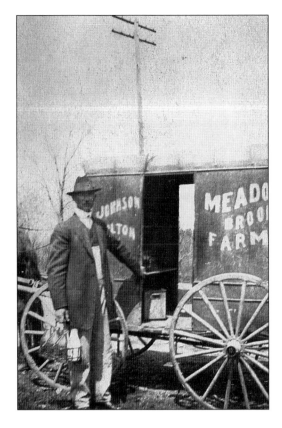

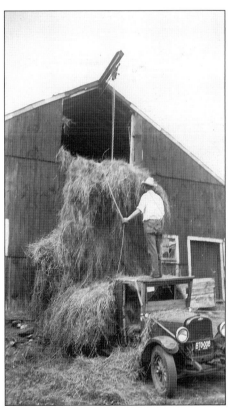

The old Ford is unloading hay at Meadowbrook Farm. The large hayfork is attached to the roof pulley, which draws the hay into the barn, where it is distributed in the mow.

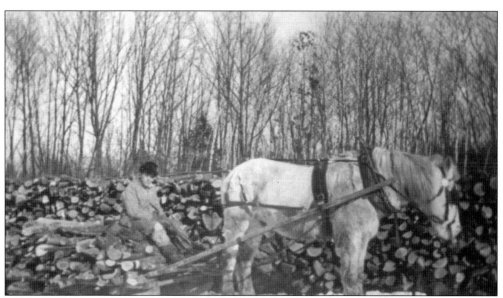

Michael Devlin worked each winter cutting cordwood near his place on Haggerty Road. This 1910 photograph shows Devlin and his faithful horse.

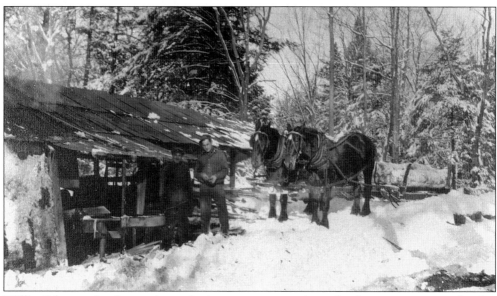

Willis Baker, a local prominent businessman, ran a large lumbering operation. In this photograph, two unidentified men and their team stand bedside Baker's sawmill in the snowy winter of 1932.

Men are seen here harvesting ice on Tucker's Pond. This early-1900s photograph shows Justin Putnam, H. West, Lewis Blodgett, and a Mr. Cone running ice up the chute to the icehouse, where it was packed in sawdust for summer use.

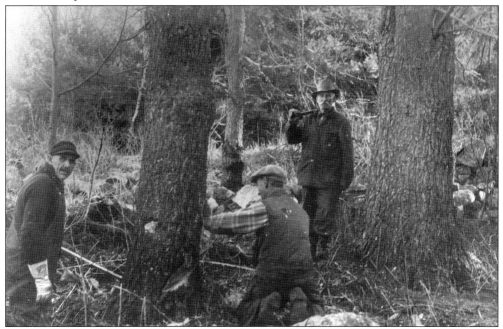

Crosscut saws and axes were the tools of the woodsman until the advent of the chain saw. Aden Bond (left) assists an unidentified sawyer while Jesse Westerlund shoulders the ax to fell this pine in 1910.

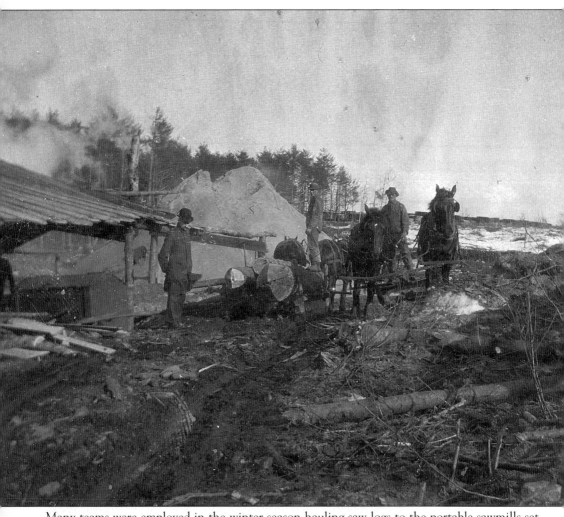

Many teams were employed in the winter season hauling saw logs to the portable sawmills set up in the woodlots. This 1905 picture is of the Tucker portable mill.

Four
SOCIAL AND LEISURE: PEOPLE

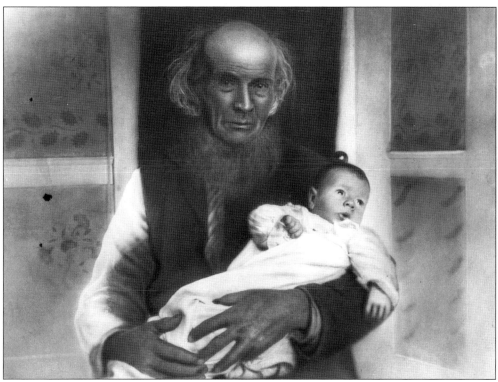

This nostalgic photograph pictures baby Lumon Turner in the arms of his maternal grandfather, Solomon Williams, in 1897. Turner died in 1981. The walls of the Turner house were finely stenciled in several patterns. In 1940, fire destroyed the house, located on the northern side of Turner Road near the bridge over Little River.

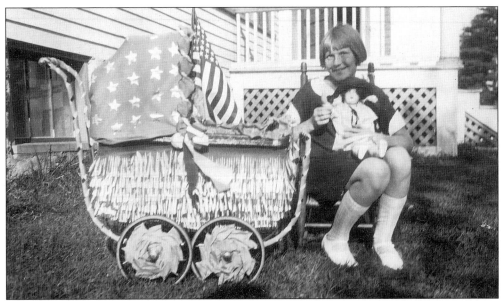

Myrtis Bracket is shown here with her decorated doll carriage for the Old Home Day Parade in 1928.

This ford was located on the old Worcester and Stafford Turnpike before a culvert was put in to carry the waters of Wheelock Brook under the road. Brothers Edwin and Warren Russell enjoy watching the geese paddling in the brook. The Russell barn in the distance was taken down in the 1950s.

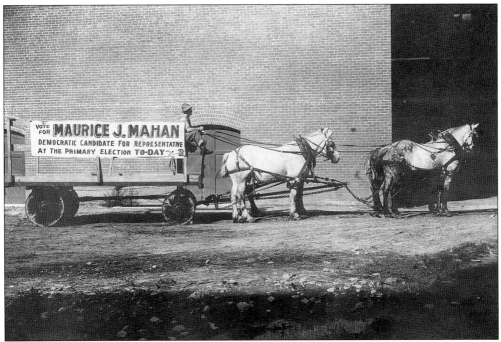

Maurice J. Mann, candidate for state representative from the Charlton District, used a two-team wagon to encourage voter turnout in 1920.

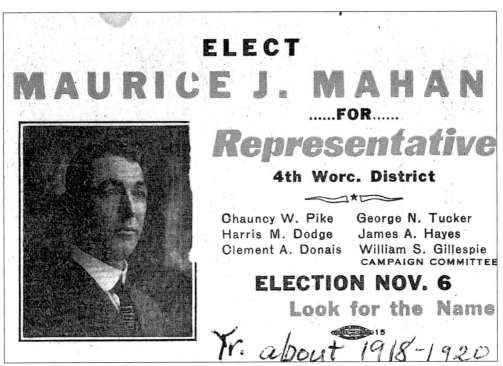

In his campaign for state representative from the local district, Maurice J. Mahan distributed these cards.

Fur is in fashion! Here we see Jenny Ferguson and her mother, Melvina Stevens Bracket, at their home on Sturbridge Road in 1922.

Here we have summer delight. Baby John P. McKinstry is shown in a wicker chair.

This stylish young couple is Pliney Bracket and his wife, Josie.

This is the grand march of the Class of 1963 junior prom. Class president, Marilyn Johnson, with her escort, John Miller, lead the line.

Mary Murphy Price was housekeeper at the Charlton Inn on Stafford Street in Charlton City. Price was employed for 14 years by Charles L. and Minnie Vizard.

Cowgirl Marilyn Johnson smiles for her father in this 1953 photograph, taken at her home on Brookfield Road in Charlton City.

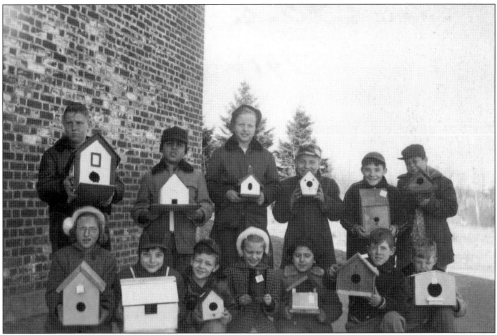

This photograph was taken at the Charlton Center School in 1954. Classes in building birdhouses were held. From left to right are the following: (front row) Joanne LaRoache, unidentified, Peter Fleming, Georgia Cook, unidentified, Francis Clark, and unidentified; (back row) Ronald Denault, James Loconto, Marilyn Johnson, Russell Caplette, Stanley Burlingame, and Howard Oliver.

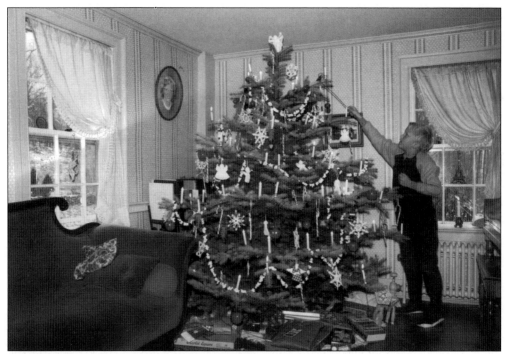

Putting candles on the Christmas tree is an old tradition in many homes. On Christmas Day, Carl Hultgren extinguishes the candles on the tree after the gifts have been opened.

This is a photograph of Howard Hammond. "Don't Bother Me!"

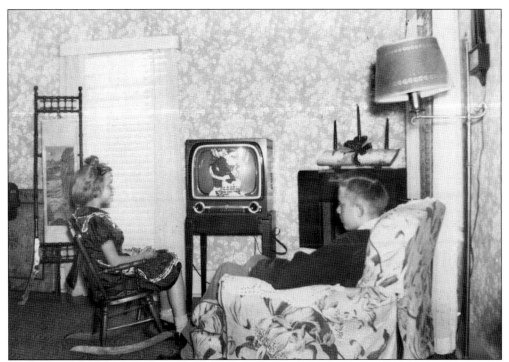

Television has arrived! Here, we see the first television set in the home of Wilbur and Myrtis Johnson. Their children, Marilyn and Wilbur A. Johnson, enjoy a Christmas cartoon in 1950.

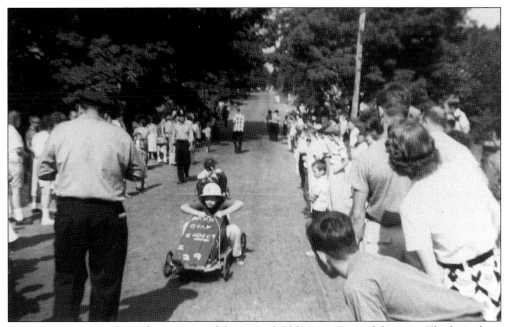

A soapbox race has always been a part of the annual Old Home Day celebration. The long slope of Masonic Home Road is the ideal place to try out the homemade vehicles. In this 1959 snapshot, two contestants cross the finish line.

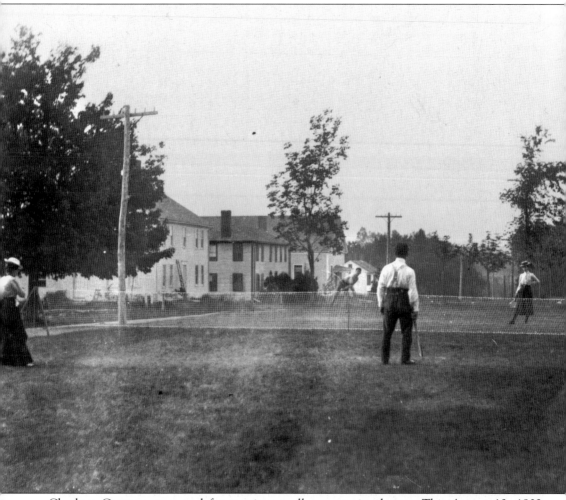

Charlton Common was used for tennis as well as pasturing horses. This August 13, 1902 photograph shows a doubles match between partners Jessie Williams Mann and Ernest Carpenter. On the far side of the net is an unidentified man serving, with partner Elsie Sweet watching the serve. Sweet's outfit is quite daring with its short skirt. Mann's attire is more in keeping with this 1902 photograph.

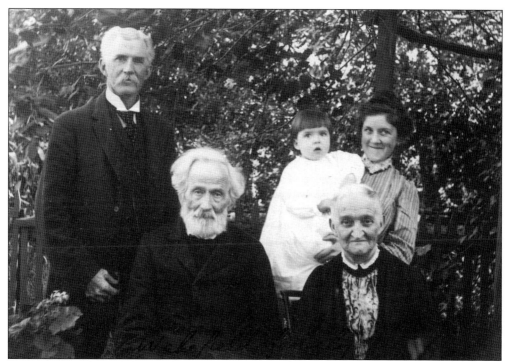

This 1895 Woodbury family portrait shows, from left to right, the following: (front row) Moses David Woodbury (1821–1897) and Louisa Allen Woodbury (1830–1918); (back row) Frank Wakefield, his daughter, and his wife (daughter of Moses David Woodbury).

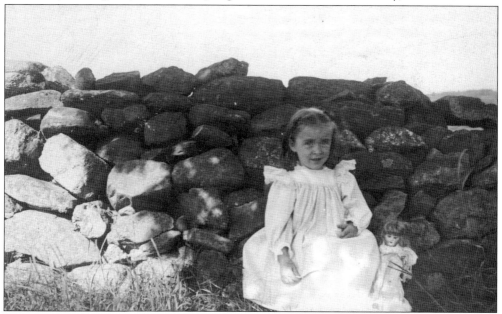

Dorothy Woodbury is shown in this 1904 view. Woodbury was born on February 29, 1896, a leap year. The year 1900 was not a leap year, so Dorothy had to wait until 1904, as she said, to have her first birthday. She lived her whole life in the house on Charlton Common in which she was born.

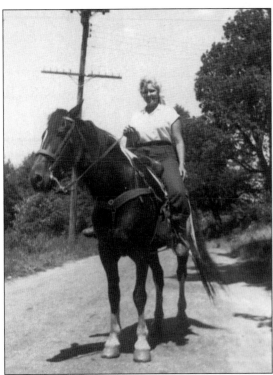

Riding horses has always been a popular activity in Charlton—on the many small lanes and roads. In this photograph, we see Eleanor Hultgren on horse Pat on Northside Road in 1953.

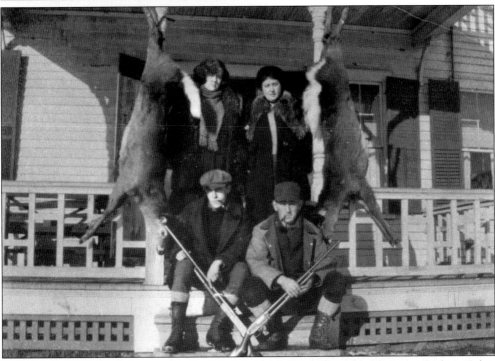

The woods also provided game for the fall deer hunt. Here, the proud hunters, Robert Baker and LeRoy Vizard, display their success. The ladies, Laura Vizard and her companion, join the hunters at their Main Street home.

In this 1921 view, a dapperly dressed raccoon hunter displays his catch.

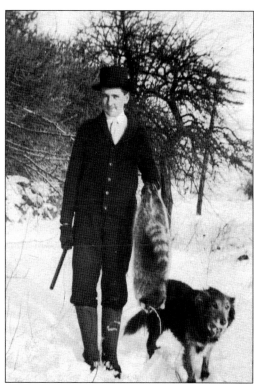

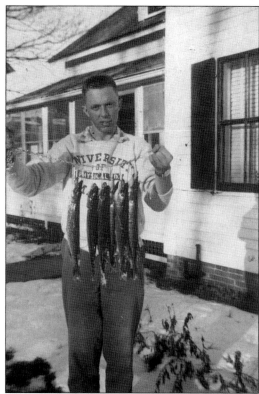

Fishing at local ponds always rewarded the angler with a good catch. Wilbur A. Johnson proudly displays his catch in front of his Brookfield Road home in 1959.

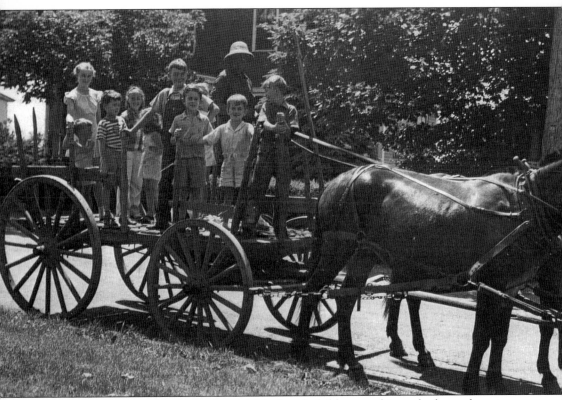

John Stevens gives a ride to the neighborhood children on his mule-drawn hay wagon at Charlton Center in 1951. From left to right are the following: (front row) Richard Moffatt, Gordon Baker, Nancy Baker, Leland Baker Jr., Richard Shea, and Roger Bond; (back row) Barbara Moffatt, Joan Mushroe, Edward Shea, Muriel Davis, and John Stevens (at the reins).

Five
MILLS AND COMMERCE

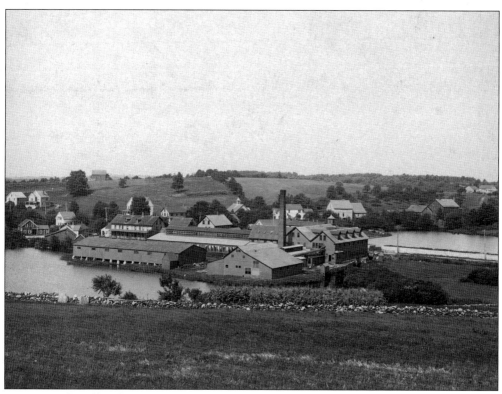

Spring Brook Mill is the complex of mills formerly known as the Upper Mills. It took its name from a small stream, which joins Cady Brook at Charlton City. In 1878, Edward Akers acquired the Thayer, or "Upper," water privilege after dissolving his partnership with Nathan Norris. Akers built the earlier part of the company, which processed and wove wool cloth. On the far left, the dark building is the J.A. Haynes blacksmith shop. On the far right, the dark buildings are the Prouty Wire Mill, or the Prouty Charlton Wire Company.

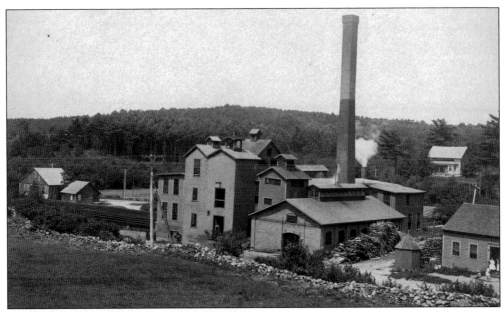

Cady Brook Mill of the Akers & Taylor Company is shown in this 1900 view of the "Lower Mill." All the finishing and dying of the cloth woven at the upper mill was brought down and done here. The 1893 rear addition was heavily damaged in 1938 by floodwaters that accompanied the hurricane. The cloth-drying, or tedder, frames stretch away to the left. The old tollhouse of the Worcester and Stafford Turnpike appears in the lower right.

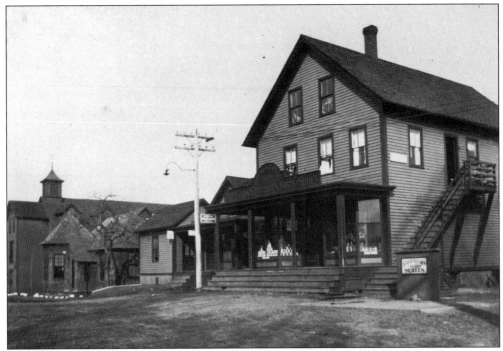

The Akers & Taylor mill store on City Depot Road serviced the employees of the mill and others. In the background can be seen the Akers & Taylor mill office. Both buildings were destroyed in the disastrous flood of 1955.

This view shows Edward Akers, manufacturer and partner in the Akers & Taylor manufacturing company in Charlton City.

Pictured is Melina Akers, the wife of Edward Akers.

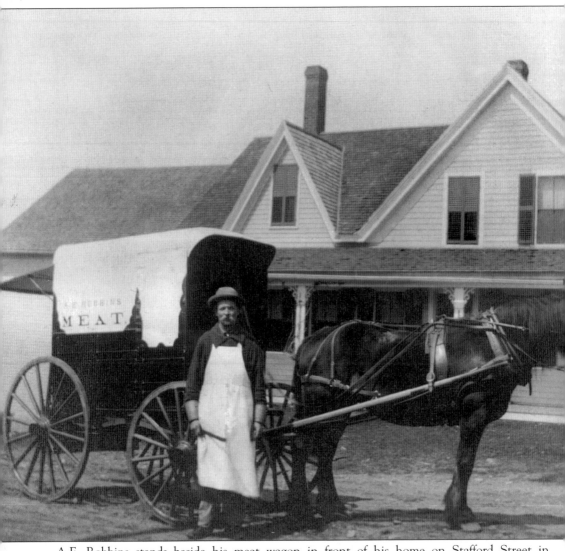

A.E. Robbins stands beside his meat wagon in front of his home on Stafford Street in Charlton City.

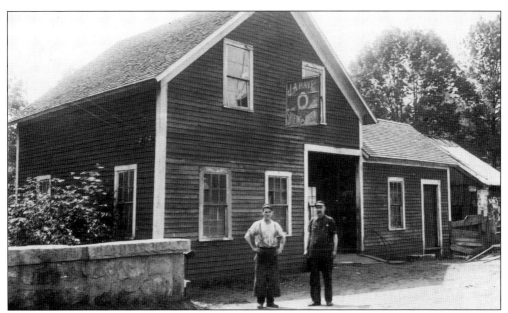

The Hayes blacksmith shop was located by Cady Brook at the Brookfield Road bridge for more than 30 years. James A. Hayes not only did shoeing and farrowing at the shop but repaired and sharpened tools. His forge was busy each day. Hayes is on the right in this photograph. His helper is unidentified. Raymond Lemilin later operated the shop. In later years, a farrier drove to the farms with a portable forge to do shoeing.

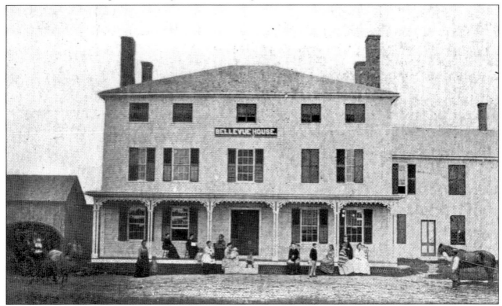

Belleview House was a popular summer hotel during much of the 19th century. Gen. John Spurr is said to have built the hotel c. 1800. The hotel, with the adjacent attached brick store, burned in 1885. The lot on which the Belleview House sat remained vacant for many years when purchased in 1903 by William H. Dexter. On the site, he commissioned sculptor T.J. McAuliff to create the monument erected in the memory of those Charlton men who served in that conflict.

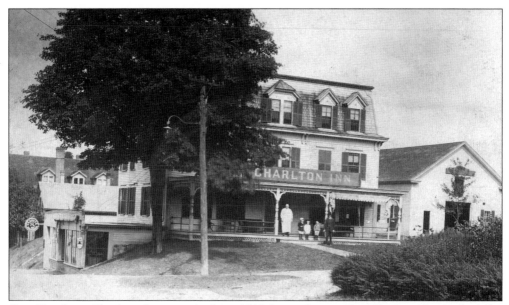

City Hotel, or Charlton Inn, was built *c.* 1810 by innkeeper Otis Farnum. Located at the northwest corner of Stafford Street and Brookfield Road, it long played a major part of the Charlton City scene. The mansard-style, or French, roof was added to the inn at the beginning of the 20th century, replacing the original monitor roof. Charles Vizard became the innkeeper at that time and expanded the facilities by adding an icehouse and later a garage for motorists. In the basement on the left, or Brookfield Road side, was the barroom. When Prohibition was voted in, Hattie Young opened a bakery in this space. Fenno J. Sinclair was the innkeeper when the hotel burned in 1927. On the site, a bungalow-style house was soon built.

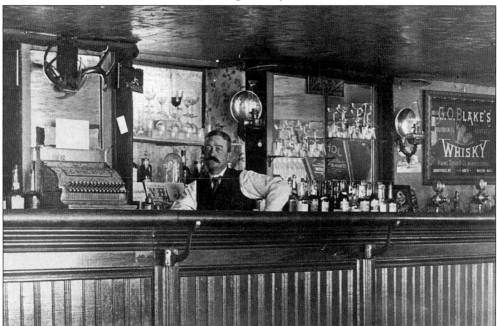

When the Charlton Inn had a liquor license, spirits were dispensed by barkeep Herbert Shaw. This 1910 photograph shows Shaw behind the bar.

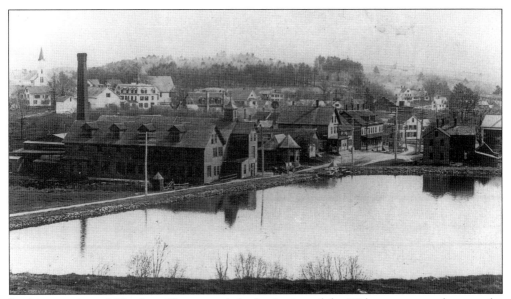

In this overview of Charlton City around the beginning of the 20th century can be seen the Spring Brook Mill of the Akers & Taylor Manufacturing Company in the foreground above the waters of Casey Pond. The office, company store, and tenement house are seen on the road beyond the dark building. On the right was the original Sacred Heart Catholic Mission Church. The new Roman Catholic St. Joseph's is in the upper left. To the right of the smokestack is the three-story Charlton Inn, above which can be seen the Charlton City Methodist Episcopal Church in its new location.

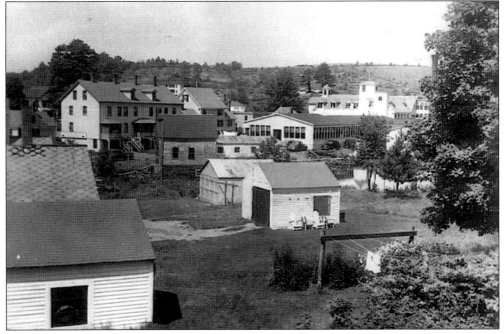

This backyard view of Charlton City from Strafford Street was taken in 1947. The large building in the top left is the tenement house of the Charlton Woolen Company. To the right of that is the long row weave room of the Spring Brook Mill.

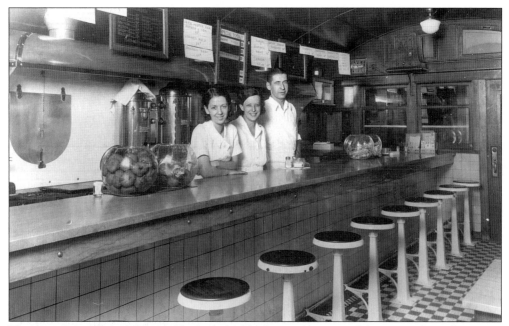

The heavily trafficked Route 20 through Charlton was serviced by a number of eateries, including the Miss Charlton Diner. This c. 1930 photograph shows, from left to right, Anita Gale, Evelyn Perks, and Cyril Perks. The diner was destroyed in the flood of 1955. It was located where Robert Christiansen's service station is today at the corner of Worcester Road (Route 20) and Southbridge Road (Route 169).

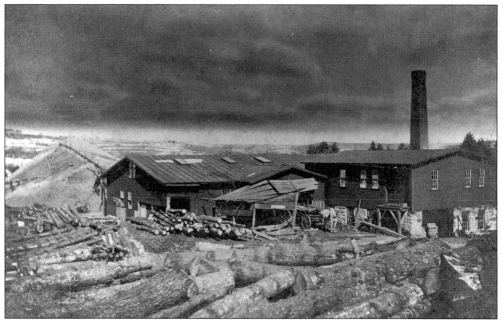

The Putnam Box Shop and Sawmill was located at the outlet of Putnam Road, north of Richardson's Corner Road. The shop in this photograph was burned in 1927, and another shop was immediately built. The new shop burned in 1947, after which it was sold to the Joslin Diabetic Camp.

Born in Sutton, Alfred Frederick Putnam as a young man joined his family enterprise, the Putnam Box Shop (today the Joslin Diabetic Camp), located on Putnam Pond. He married Mary Howe, joined the Howe family at their farm, formerly located on A.F. Putnam Road. He served nearly a half century on the school committee as well as other town offices. Both his daughters, Florence and Nellie, became schoolteachers, both serving 50 years in the school system.

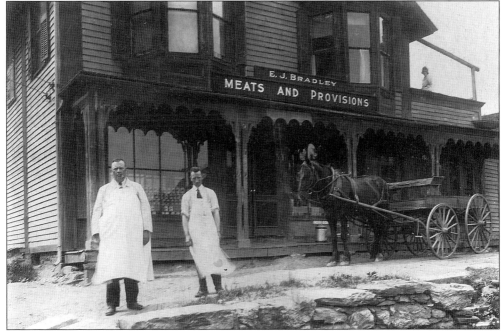

E.J. Bradley acquired the store and Charlton City post office from Clarence H. Mann in 1909. The building, with its distinctive roofline, is located at the corner of Brookfield Road and the closed section of South Sturbridge Road. Ellis J. Bradley is on the left with an unidentified clerk. The original photograph identifies the woman on the second-story porch as a Mrs. Robbins.

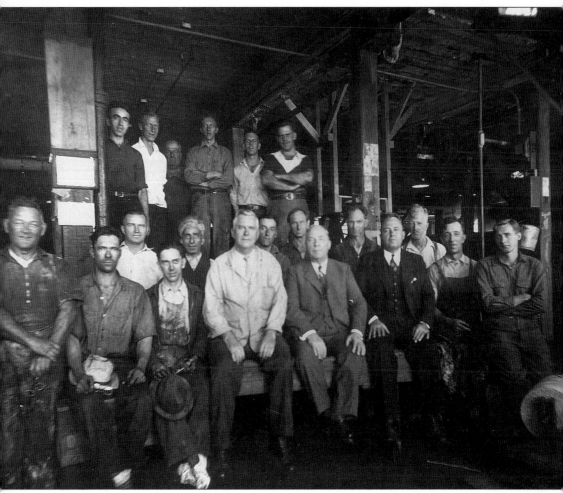

The employees and owner of the Aldrich Manufacturing Company are shown in this 1935 photograph in the mill on Sturbridge Road. From left to right are the following: (front row) J. Murray, J. Ellis, A. Lord, R.A. Bracket, owners James Ashworth and Ralph Ashworth, W. Davis, and C. Locke; (middle row) M. Hemingway, M. Venturino, E. Eastman, A. Saunders, E. Barnes, and A. Ballard; (back row) H. Robidoux, Walter Johnson, F. Burrows, Wilbur Johnson, and A. Barnard.

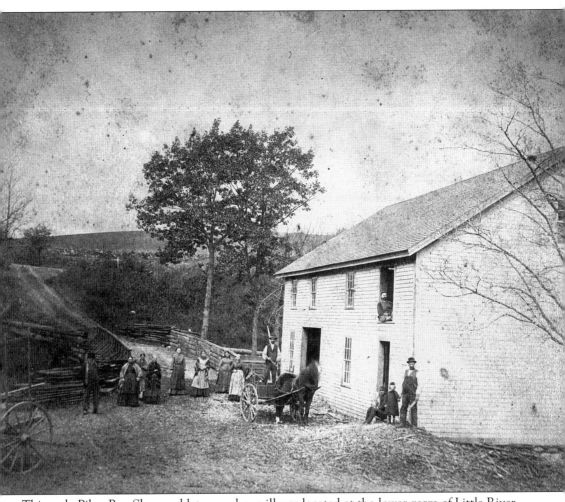

This early Pikes Box Shop and later woolen mill was located at the lower gorge of Little River at the Hammond Hill Road bridge, called Pike's Bridge. As early as the last decade of the 18th century, a series of mills was located along this stream, giving the locality the name Millward. Pike's mill burned and was replaced in 1879 by a shoddy mill.

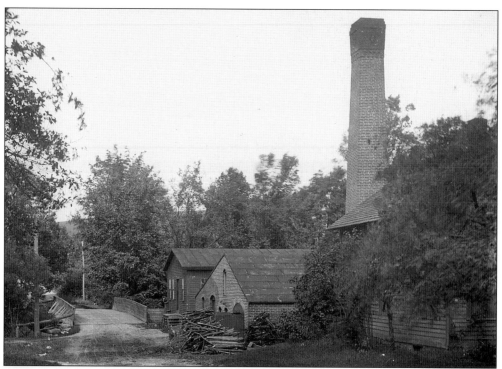

This brick and wooden structure, Pike's Millward Mill, replaced the mill that burned in 1879.

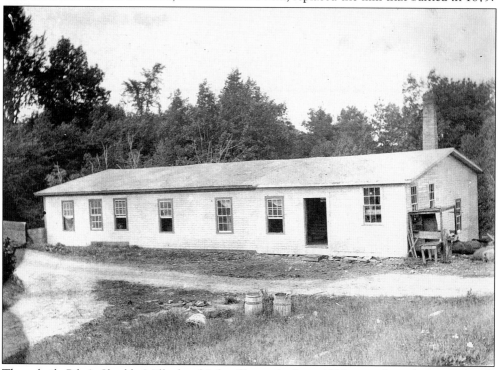

The rebuilt Pike's Shoddy Mill, the third mill, was built in 1897 to replace the second mill, which had burned in April of that year.

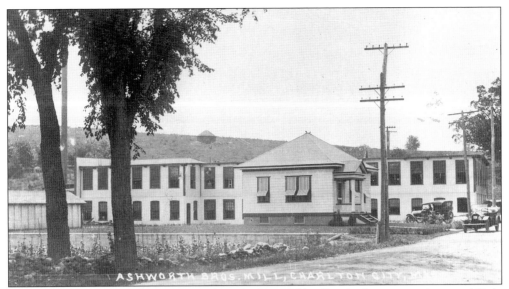

The Ashworth Mill on Sturbridge Road was built on Sibley Brook, the major tributary of Cady Brook. The first to use the waterpower here was Lyman Sibley, who built a gristmill in the early 1800s. He sold to Meritt Aldrich and Reuben Wallis, who built a large mill for the manufacture of woolen cloth in 1880. The Ashworth family bought the mill in 1903, and a fire destroyed the mill two years later. The mill was immediately rebuilt but, in 1920, burned again. It was replaced by the present concrete structure.

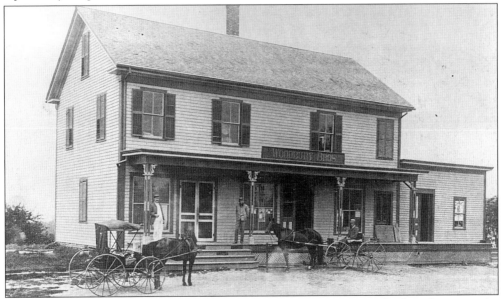

The Woodbury brothers built the new store on Main Street in 1886 at Charlton Center on the spot where the old General Spurr brick store had burned. After the Woodburys declared insolvency, the Baker brothers acquired the post office and store. This 1916 postcard view shows, from left to right, Lewis Baker, Henry H. Baker, Royal Baker, Clarence Knight, and Andrew Stone. After the store and post office was moved to the new Dodge store at Bond Square in 1932, the grain store on the right was moved back and remodeled into a dwelling. The main building was made into a two-family house.

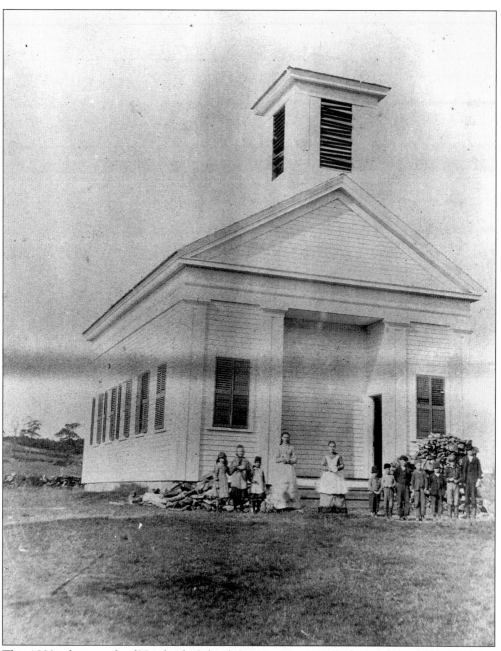

This 1880s photograph of Northside School, District No. 2, with the teacher and the students is one of the earliest photographs we have of this large one-room school. It is often mistaken for a church because of its belfry and spire. (There was previously a Baptist church on the same foundation.) The school was closed in 1949.

Six

SCHOOLS

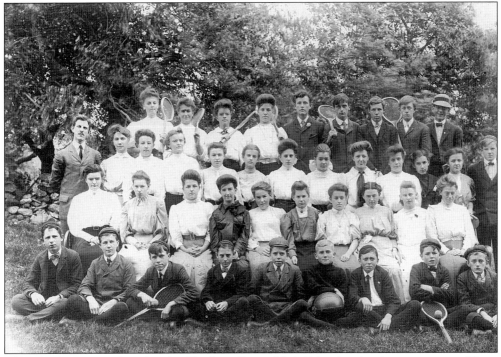

These students are gathered at the Charlton Center High School under the supervision of Perry Howe, first principal, who also taught several subjects. The assistant teacher is in the rear on the left. The tennis and basketball clubs are represented here.

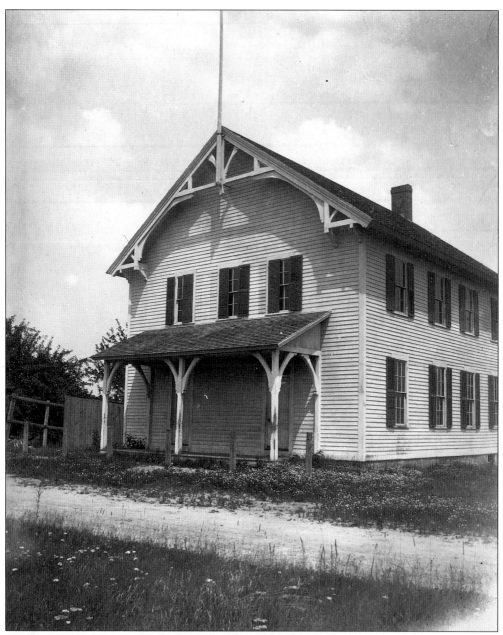

Charlton High School and the District No. 1 school were located on the east side of the Charlton Common, north of and adjacent to the current municipal building. Built in 1878, it served as the District No. 1 school on the ground floor and for town offices on the second. In 1905, a high school was established in the former town offices. The building, as well as the adjacent Universalist church, was destroyed by fire on May 23, 1922. A new school was built on the church site, today's George McKinstry III Municipal Building.

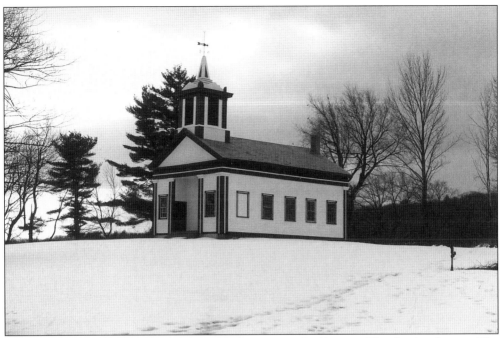

In 1990, Charlton received a grant toward restoring the District No. 2 schoolhouse. The restoration work done shows the efforts of many individuals. The building is now used for meetings and the Charlton Arts Council.

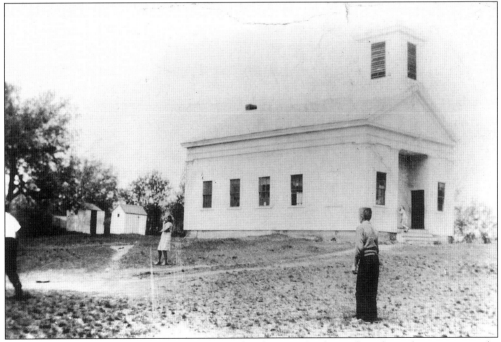

Here is a view of school recess at Northside School in 1945. Classes four through six were taught here by one teacher. Students often say that they felt as one big family. In this view of a softball game, Barbara Snow is pitching while Ira Hammond is on the right in a fielder's position.

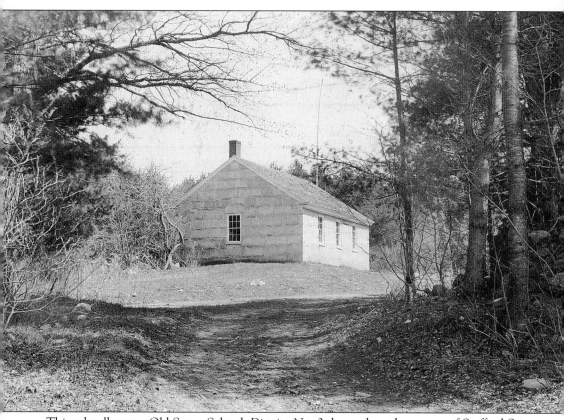

This schoolhouse—Old Stone School, District No. 3, located on the corner of Stafford Street and Hammond Hill Road—was built of granite from the Woodbury quarry in south Charlton in 1837. It was the only stone school in town. The school was closed in 1925 and burned in 1930 from arson. In 1841, summer school was held here, taught by Clara Barton of Oxford, who later earned the name "angel of the battlefield" for her work on the Civil War battlefields and as founder of the American Red Cross.

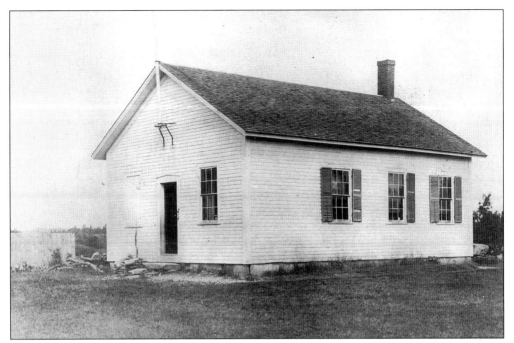

The District No. 4 school was built c. 1880 to replace the earlier 1770s school. Classes were held here until 1949. The schoolhouse was sold at auction and used as a leather shop for some years. The remodeled and added-onto building is now a dwelling.

The old District No. 4 school, built c. 1770 on Richardson's Corner Road, was made into a home complete with barn and sheds when the new District No. 4 school was built nearby in the 1880s.

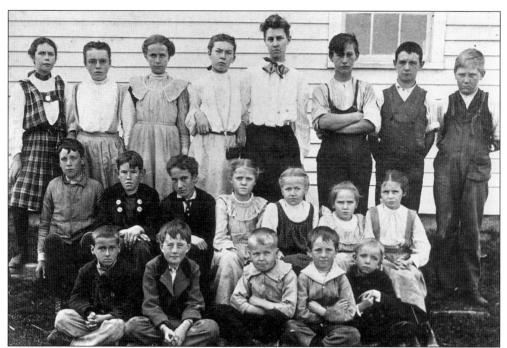

Students at the District No. 5 school are shown in this 1900 photograph. This schoolhouse was located on the north side of A.F. Putnam Road, a short distance below the Putnam farm. School was kept here by Nellie Putnam until 1932. Arsonists burned the abandoned school on July 4, 1941.

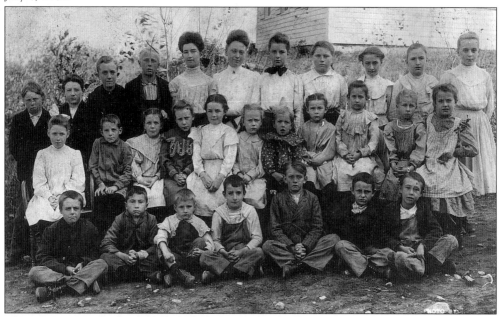

This 1905–1906 photograph of Parker School, District No. 6, shows teacher Jennie Foskett in the back, sixth from the left, with assistant and students in grades one through eight. This school remained in use until the 1949 consolidation of the rural schools. Lucy Stevens last taught here.

Agustus Abell displays a bountiful harvest for the camera in front of District No. 7 schoolhouse c. 1905. The 1870 schoolhouse in the background replaced the old 1760 schoolhouse. The Harvey Dresser Cemetery, removed to Southbridge in 1986, shows in the background. The Dresser Hill Dairy Bar is today located on the school site.

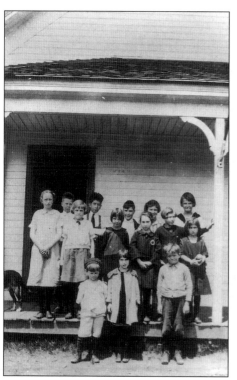

Carpenter Hill School, District No. 9, was built in 1890 to replace the earlier schoolhouse, which was on Tinker Hall Road. This 1920s photograph shows the students on the front porch of the schoolhouse. They are, from left to right, as follows: (front row) Alexander Krasows, Florence Bergmark, and Albert Wilson; (middle row) Anne Wilson, Anna Bergmark, Jessie Hall, Evelyn Mann, and Lena Krasowsky; (back row) Alice Phillips, Paul Meeson, Gardner D. McIntire, David Bergmark, Elsie Wilson, and Olga Krasowsky.

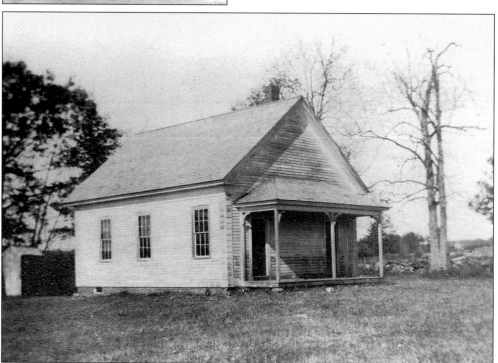

This photograph shows Carpenter Hill School, District No. 9, as it appeared in 1920. In 1937, after much discussion, the school was discontinued and the students were bused to the Charlton City Grade School. The schoolhouse is now a private home.

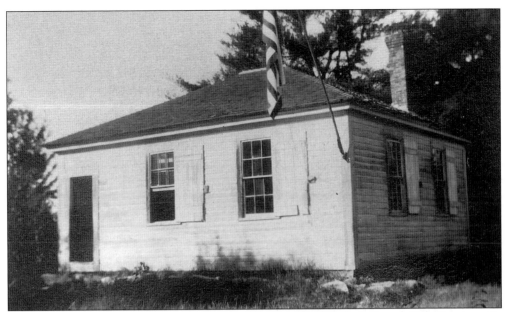

Barefoot School, District No. 10, was a very old school building, which stood on the west side of Schoolhouse No. 10 Road and served district scholars until 1919. It was then sold to a neighbor who tried to move it to his farm a short distance away. He found that it was so deteriorated that it fell apart in the middle of the road. The salvaged lumber was used in his new barn.

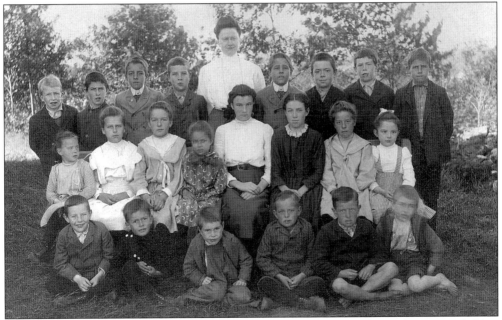

Charlton Depot School, District No. 12, is shown in this 1920s snapshot. Classes were held in the old "northwest district" on the "path to Brookfield" as early as 1770. The one-room schoolhouse was located on the east side of Curtis Hill Road until the 1870s, when a new building was erected. This structure was moved to its present site on Little Muggett Road c. 1900. The school closed in 1934 and was sold for a private dwelling.

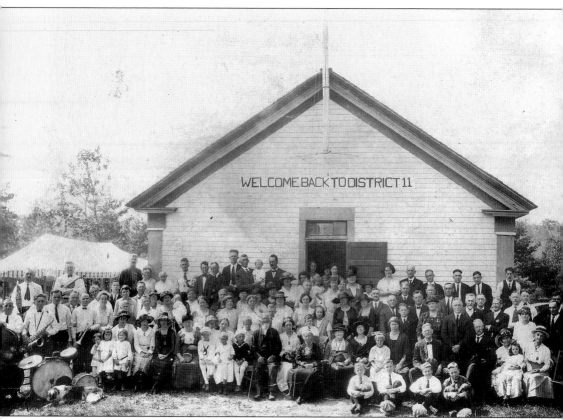

The District No. 11 schoolhouse was located on the triangle of land at Brookfield and Sullivan Road North. The schoolhouse was center of social activity in the district. In this 1924 photograph, the residents and schoolchildren are gathered for a social. On the left is a group of musicians led by district resident Lauritz Nielsen.

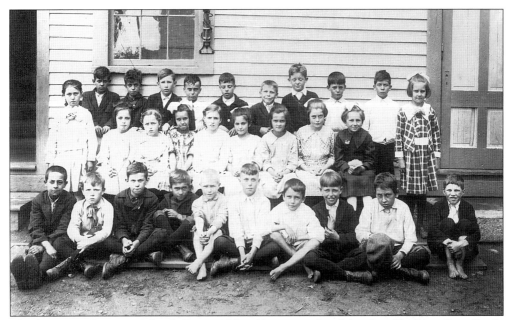

Charlton City Primary School, District No. 13, was replaced by the Charlton City Grade School in 1899. This school was then used for the younger classes, kindergarten through second grade. This 1920 photograph shows the students in front of the school, many of whom are enjoying the summer weather in shorts and bare feet.

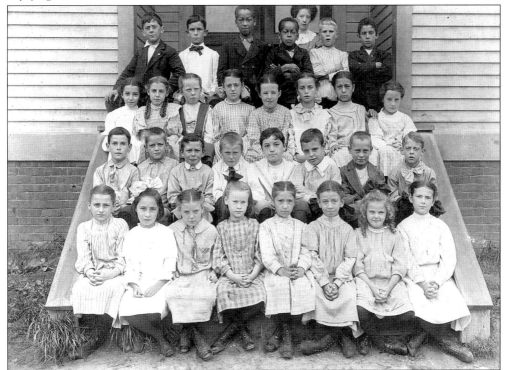

Students of grades three through six pose with their teacher on the steps of the Charlton City Grade School for this 1910 picture.

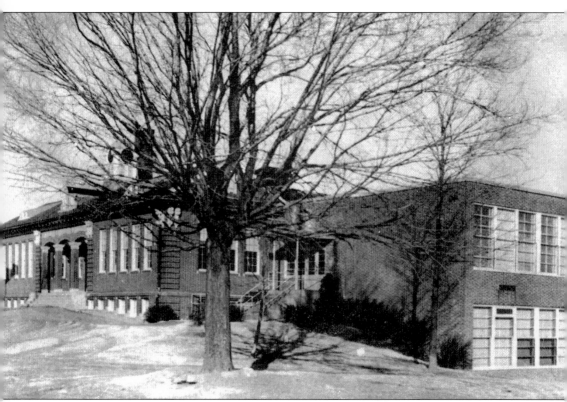

The Charlton High School was built in 1923 on the site of the Universalist church, which had been destroyed the previous year in a fire. After heated debate, it was voted to accept the donation of land from the Universalist Society on which to build a new high school. The school served grades 8 through 12. In 1949, the two wings were added to accommodate the closing of the rural one-room schools. Upon completion of the regional school in 1973, the building became the intermediate school. A new elementary school opened in 1986, leaving the building empty. The town, after discussing several options, decided to use the building for much needed town offices. Today, the George McKinstry III building houses the Charlton municipal offices.

Seven

DISASTERS: FIRES, FLOODS, HURRICANES, AND STORMS

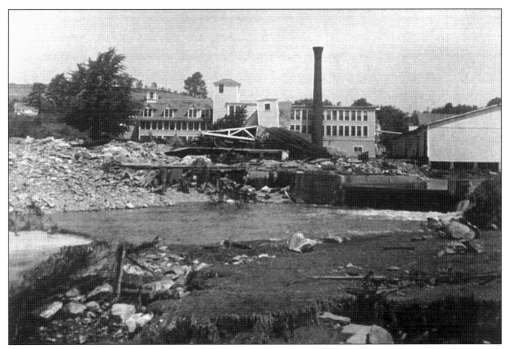

The havoc wrecked on Charlton City by the bursting of the Glen Echo Lake dam from torrential rains in August 1955 is clearly seen in this photograph of the upper mill of the Charlton Woolen Company.

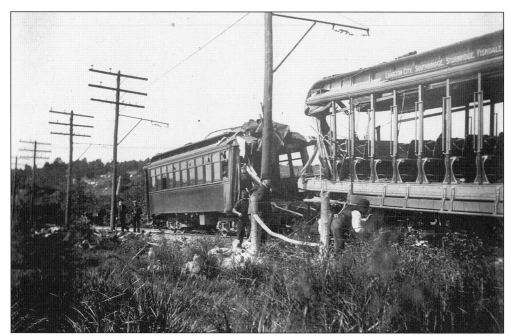

Two cars of the Worcester & Southbridge Street Railway met head-on half a mile south of Route 20 on August 29, 1907, on the Southbridge Road. The closed car was outbound from Southbridge, while the open car traveled from Charlton to Southbridge on the single track. The motorman of the closed car was killed, and the motorman on the open car was seriously injured.

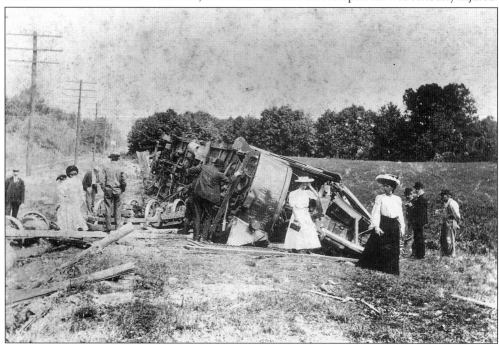

This 1905 view shows the wreck of the special trolley car on its way to Worcester after the Labor Day Ball. One young woman was killed when the car jumped the tracks on Hammerock Curve. The ball was part of the dedication of the new town hall.

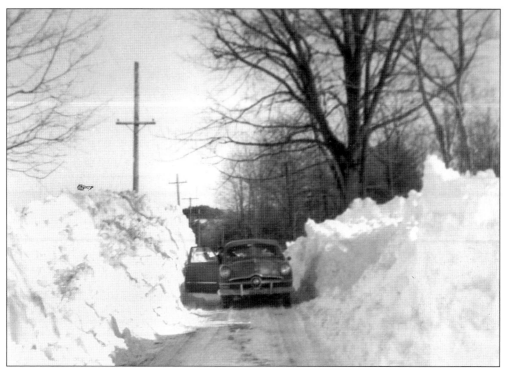

This wintry view of February 1961 shows Little Muggett Road drifted in with snow near H.K. Davis Road.

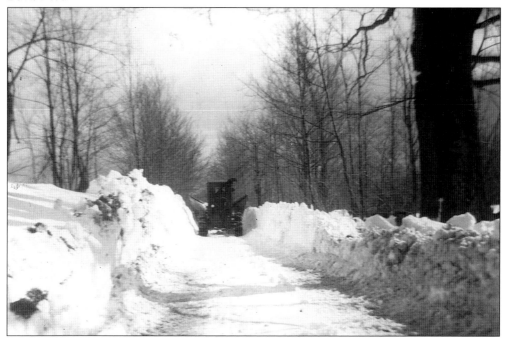

A newer version of the old-fashioned snowplow first used in the 1920s to clear the roads is shown in this 1958 view of the grader equipped with a V-plow and two wings clearing the snow on Fitzgerald Road.

After the 1955 flood, the U.S. Army Corps of Engineers dredged a new channel for Cady Brook from Southbridge to the Massachusetts Turnpike construction site. The dredge here is passing the former Casey's Pond, heading toward the burst dam of Cider Mill Pond. Doc Clark's cider mill is to the left of the dredge.

This is the view from the opposite direction of the preceding photograph. The photograph was taken from the remains of the dam of Doc Clark's Cider Mill Pond, looking downstream to what was once Casey's Pond and the upper mill, or Spring Brook Mill, of the Charlton Woolen Company. The destructiveness of the floodwaters is clearly illustrated.

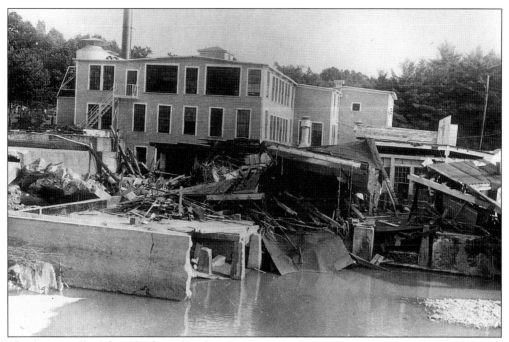

The lower mill of the Charlton Woolen Company on Route 20 was severely damaged by the floodwaters. After passing the bridge on Brookfield Road, the floodwaters burst Carpenter Pond and the lower millpond, adding their waters to the rushing torrent.

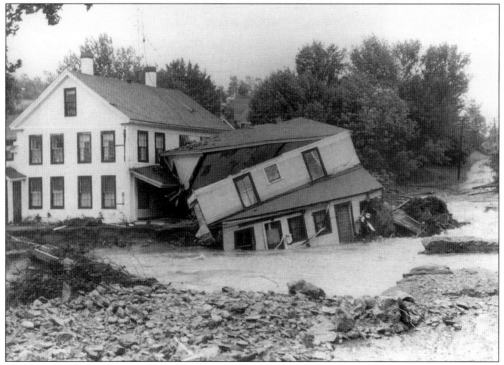

The Lincoln home was washed from its foundation in the flood. It is shown here resting against the Everett Beckwith house on Power Station Road.

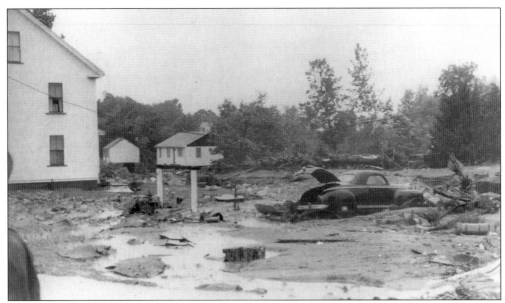

Ralph Drake's house on Power Station Road is on the left, and the gable end of Frank Ashe's house is on the right. The present Charlton City post office occupies the spot above the car. Power Station Road is unrecognizable in this 1955 photograph.

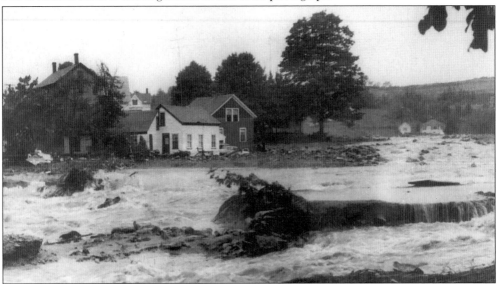

The old Charlton City post office is on the left with the two chimneys. Ed Steadman's house is the white one, and the next house to the right is that of Edward Langlois. The floodwaters had rushed down the bed of Cady Brook to Charlton City, first striking the fill of the Massachusetts Turnpike, then under construction. This diverted the floodwaters for a time and slowed them down. The waters then broke through, causing Cider Mill Pond and Casey's Dam to burst. Santelli's store and home was swept away from the spot where the water is flowing down next to the large tree. Four were killed in Santelli's house and store: Mr. and Mrs. Santelli, Mr. Porter (their son-in-law), and Mr. Pieranglli. Casey's Pond was a the rear of the Santelli place. The damaged Steadman and Langlois houses were later removed, creating the triangle common at Brookfield, South Southbridge, and City Depot Roads.

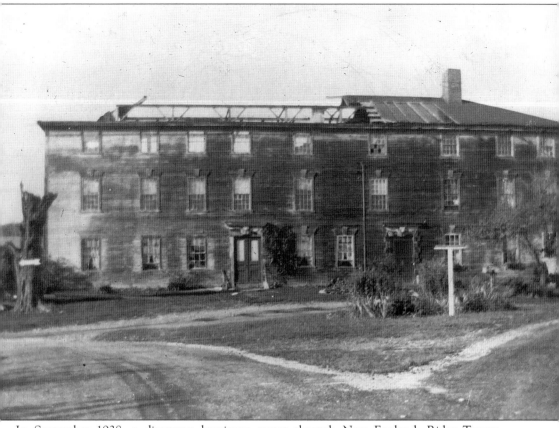

In September 1938, a disastrous hurricane swept through New England. Rider Tavern, Charlton's outstanding Federal-period inn, suffered severe damage. The building was originally constructed with a flat roof, which was later raised to the present hip roof. In this photograph, taken shortly after the storm, the west part of the 1840s hip roof was lifted off, giving us a rare chance to see the tavern with the original flat roofline. Unfortunately, the tavern remained unrepaired for several years, causing additional damage to the interior. It is now restored by the Charlton Historical Society.

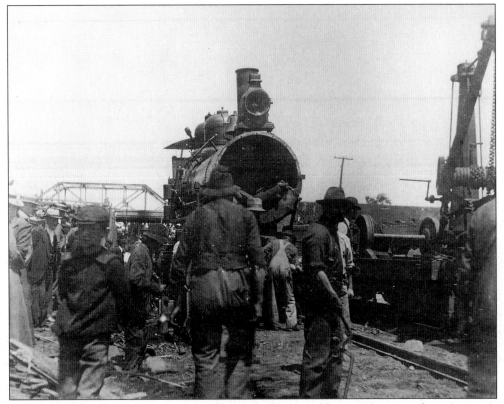

Collisions are rare on the railroad line through Charlton. This wreck occurred on August 8, 1903, nearly in front of the passenger station. Engine No. 1139 and freight train No. 2546 were somehow on the same track. Serious damage was done to both locomotives, but no deaths resulted.

The Congregational church was built in 1827, remodeled in 1856, and destroyed in a fire on Christmas Day 1939. The steeple, blown off in the 1938 hurricane, was never replaced, and the church was destroyed by fire one year later.

Edwin Phillips stands beside the horse trough at his farm on Harrington Road c. 1880. The old parental farmhouse is in its new location behind him while his new house is on the site of the old early house.

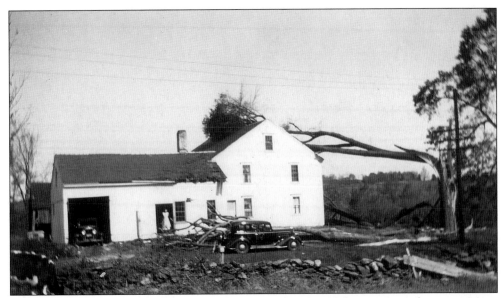

The Hurricane of 1938 was perhaps Charlton's greatest natural disaster up to that time. Many trees and woodlots were blown down. This view shows the Clark Farm on Stafford Street (later John Cook's farm) after the hurricane knocked over trees and damaged the house.

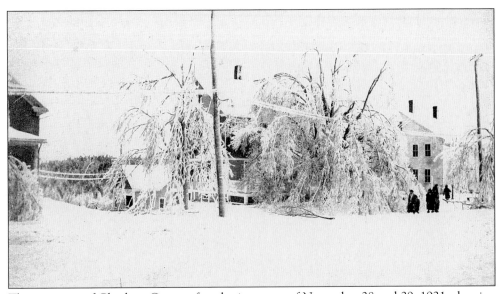

This is a view of Charlton Center after the ice storm of November 28 and 29, 1921, showing the tremendous damage to the trees caused by the ice.

Eight

Transportation: Stages, Trains, Trolleys, and Automobiles

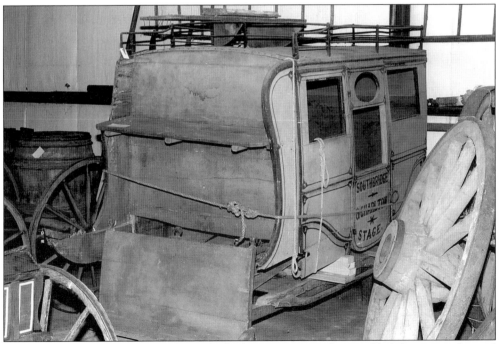

This is a picture of the Southbridge and Charlton stage in its disassembled shape, now located at Old Sturbridge Village. For many years, this vehicle carried passengers and the mail from Southbridge to the train depot in Charlton.

Andrew T. Whitney was born on May 12, 1824, and died on November 5, 1914. He was the son of Thomas Whitney, who founded a stagecoach line in 1839. Andrew served as a mail carrier on the line running from Charlton Depot over Carpenter Hill to Southbridge. He retired in 1902.

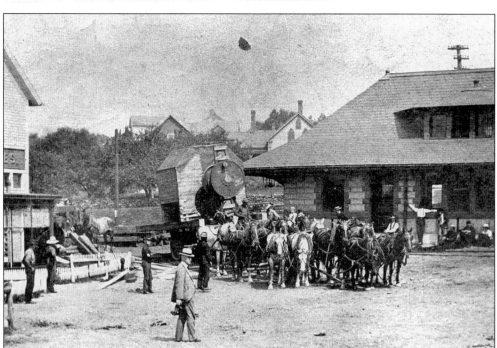

This 1903 photograph at Charlton Depot shows the moving of the electric generator, which had been delivered on the railroad, to be installed in the power station of the Worcester & Southbridge trolley line. Six teams of horses were needed to transport the generator. In the shade of the station roof are the local hangers, most likely commenting on the scene.

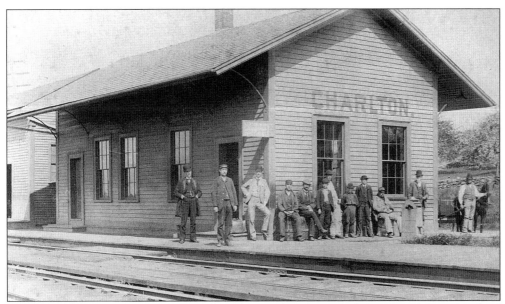

This c. 1890 photograph shows the old Western Railroad station, located on the north side of the tracks at the depot. Shown on the far left is Jonas Waite, the second station agent in Charlton, serving in that capacity for more than 30 years. The old Western Railroad station was abandoned in 1892, when the new stone station was built by the Boston & Albany Railroad directly across the tracks. The man next to Waite is Harry Truesdell, baggagemaster. Sitting fourth from the left is James McConnell, the crossing tender. When the new station was built, the crossing was eliminated and the guard's position became unnecessary.

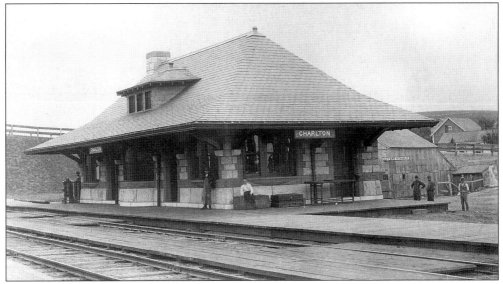

The second station at Charlton Depot was built in 1892 on the opposite side of the tracks from the first station, in what had been the middle of the old grade crossing. The building of the bridge over the tracks created a spot for a new, more convenient station. This photograph shows the brand-new station ready for business. Jonas Waite and his wife made the move across the tracks to the new station in August 1892. Waite's hobby was growing many varieties of flowers. The station at Charlton Depot was known for its neat and attractive appearance.

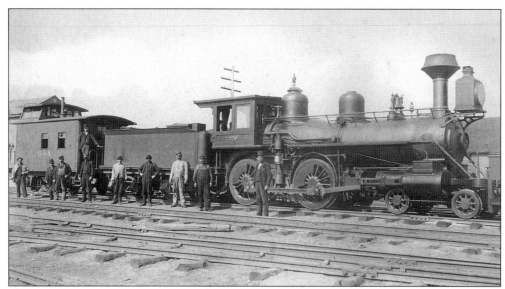

This 4-4-0 American-type engine was built by the Boston & Albany Railroad in its West Springfield shops in 1881. The engine, tender, and caboose is idling at the Charlton Depot stop in this 1892 photograph with stationmaster Jonas Waite on the platform of the caboose.

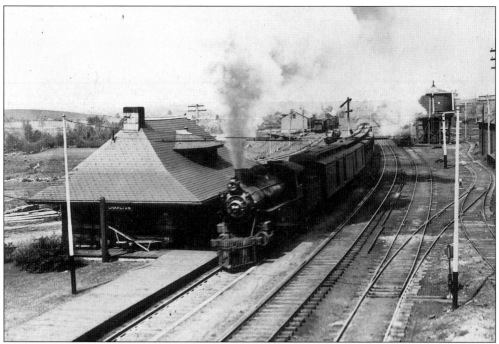

A mixed train is stopped at the station in this 1907 photograph. The siding on the far right leads to the milk house. Over four tons of milk were shipped on ice to Brighams in Boston each day from Charlton's farms.

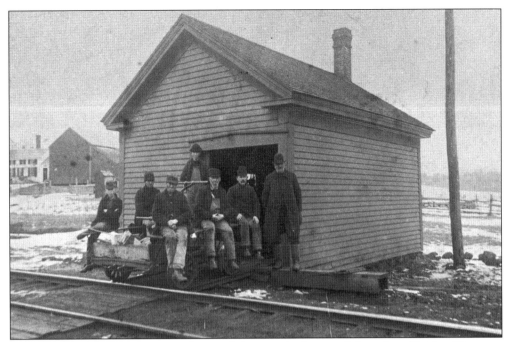

The new Charlton Depot section foreman's hut was built east of the railroad bridge. The man on the far right is George Truesdell, section foreman for the Boston & Albany Railroad for over 30 years.

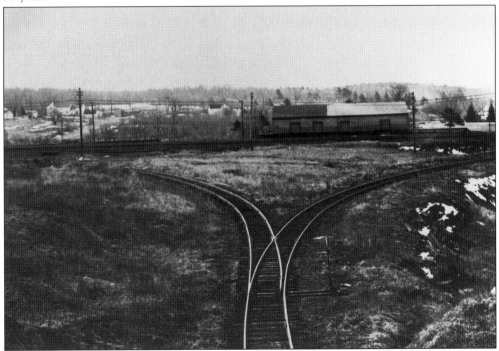

This is a photograph of the turnaround wye at Charlton Depot. This turnaround allowed the rear pusher, or helper engines, attached to the regular trains at the beginning of the long grade up to the summit to drop off here and turn around, returning east for the next train.

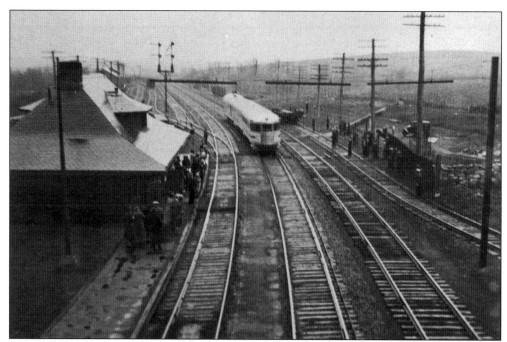

The Route 31 railroad bridge was a favorite spot for photographers to gather for important occasions on the railroad. This 1934 view shows the first diesel train to run through Charlton Depot. It was the Burlington Railroad's new lightweight diesel-powered passenger train, the "Zephyr."

The Summit House at Charlton Depot was the place where passengers took the stage to Southbridge. From left to right are Mark Gould, teamster; George Truesdell; Edith Hammond; Alita and Harry Truesdell and son Ralph; and Arthur Marimas, another teamster.

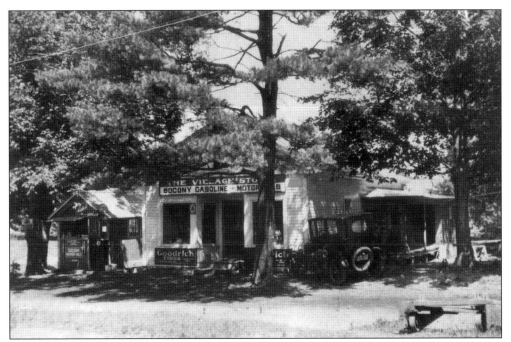

The Charlton Center Village Store and post office was built for Harris M. Dodge by Arthur Baker and son Melvin in 1923–1924. The post office was moved here in 1932 from Charlton Common. Store owner Arthur G. Dodge became postmaster. He served in that position until his retirement 35 years later. The village store remained in this location until 1959, when it was torn down and the present brick buildings were built by Silvio Carpenter and his son Armand. The new post office was built adjacent to the new store in 1961, remaining there until 1994. The post office building now houses an optical shop.

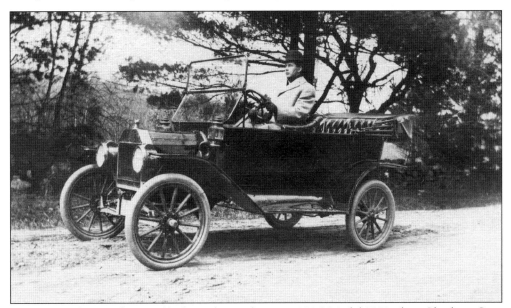

This postcard view shows Alfred Bracket in his new 1916 Model T Ford in Charlton City. Bracket worked for the Ashworth brothers' woolen company for a number of years.

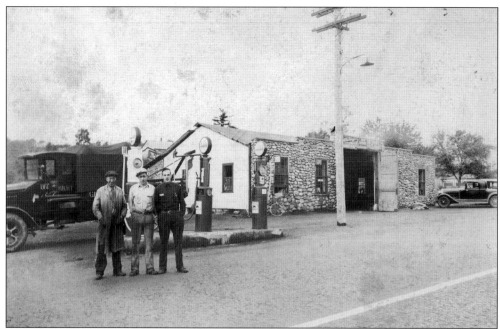

This is a photograph of Gale's Garage in 1927. From left to right are Burt Gale, Warren Gale, and Robert Mann. Gale's Garage was located at the intersection of Worcester Road (Route 20) and Southbridge Road (Route 169). Gale sold to a man named Kingsbury, who then sold it to Mrs. Sylvestery. Mr. Lawerence then acquired it, and the last to run the place was Olaf Garcia.

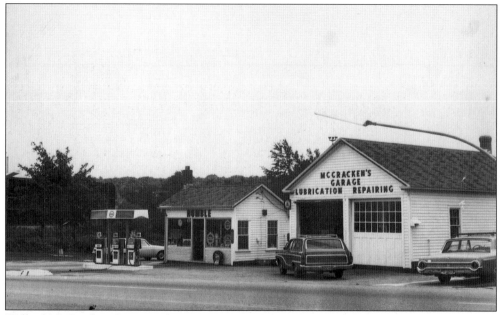

Willard McCracken Sr. opened a gas station on Worcester Road (Route 20) shortly after the new road was finished in 1928. Upon McCracken's retirement to Florida, the garage was acquired by Peter Lamountain. A 16-wheeler crashed into the office shortly after, destroying it. The garage bay was moved back, and a new office and convenience store was built.

Car No. 505 of the Worcester &
Southbridge Street Railway is waiting at
the Charlton City stop. This 15-seat
open car was built in 1907 and
remained in use until after World War I.
Another car is seen on the tracks, which
ran in a right-of-way west of Masonic
Home Road, rejoining the road at the
waiting station.

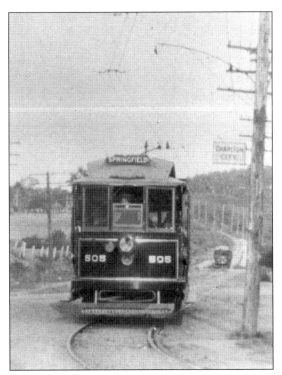

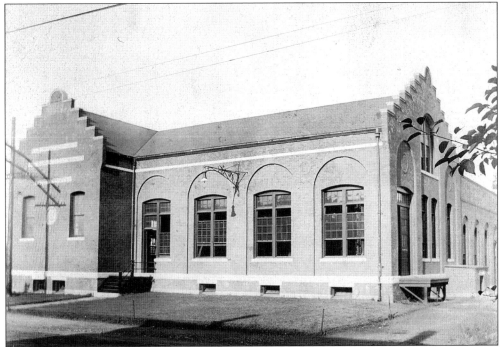

The power station of the Worcester & Southbridge Street Railway was located at a former mill
site on Cady Brook. The site is the lot of the Charlton City post office on Power Station Road.
Coal cars were brought into the station to supply the boilers of the auxiliary steam generators,
which supplemented the capacity of the water turbines producing electricity for the trolley line.

Trolley conductor Alex LaPrade and his five brothers all worked for the Worcester & Southbridge Street Railway for many years.

1903

WORCESTER & SOUTHBRIDGE STREET RAILWAY.

SOUTHWARD.

The first car for Southbridge leaves City Hall, Worcester at 6.15 A. M., and at half hour intervals, others follow till 10.45 P. M., due in Southbridge at 12.05 A. M.

Two later cars at regular intervals, the last at 11.45 P. M., run to Charlton City only, the first one due at 12.45 A. M.

The following schedule gives the stations and running time for the first car. Requisite half hours added will give the hour and minute for each successive car.

	A. M.		A. M.
City Hall, Worcester,	6.15	Charlton Center,	7.12
Stafford & Main sts.,	6.30	Overlook,	7.13
Grand View Ave.,	6.33	Charlton City,	7.15
Pinehurst Park,	6.40	Philipsdale,	7.20
Prospect Park,	6.45	Brookside,	7.24
Bryn Mawr,	6.47	Amer. Optical Co.,	7.30
West Auburn,	6.52	P. O. Square	
Tinkerhill,	6.54	Southbridge,	7.35
Oxford Heights,	6.55	Three earlier cars leave	
North Oxford,	6.59	Charlton City for South-	
Glenmere,	7.03	bridge at 5.15, 5.45 and	
Richardson's Corner,	7.05	6.15 A. M.	
Morton Station,	7.08	First car for South-	
Hammerock,	7.10	bridge leaves Worcester,	
Mashamurket,	7.11	Sunday, at 7.15 A. M.	

NORTHWARD.

The first three cars for Worcester leaves Charlton City at 515, 5.45 and 6.15 A. M., due in Worcester at 6.15, 6.45 and 7.15 A. M.

The first car from Southbridge leaves at 6.25 A. M., and others follow at half hour intervals till 10.25 P. M. At 10.55, 11.25, 11.55 P. M., 12.05 A. M., cars leave for Charlton City.

The following schedule gives the stations and running time for first Southbridge cars. For other cars add the requisite half hours.

	A. M.		A. M.
P. O. Square		Tinkerhill,	7.05
Southbridge,	6.25	West Auburn,	7.08
Amer. Optical Co.,	6.30	Bryn Mawr,	7.12
Brookside,	6.36	Prospect Park,	7.15
Phillipsdale,	6.39	Pinehurst Park,	7.18
Charlton City,	6.45	Grand View Avenue,	7.21
Overlook,	6.47	Stafford & Main sts.,	7.25
Charlton Center,	6.48	City Hall, Worcester,	7.45
Mashamurket,	6.49		
Hammerock,	6.50	First car leaves South-	
Morton Station,	6.51	bridge for Worcester,	
Richardson's Corner,	6.54	Sunday, at 6.55 A. M.	
Glenmere,	6.56		
North Oxford,	7.00		
Oxford Heights,	7.04		

Shown is a schedule for the Worcester & Southbridge Street Railway.

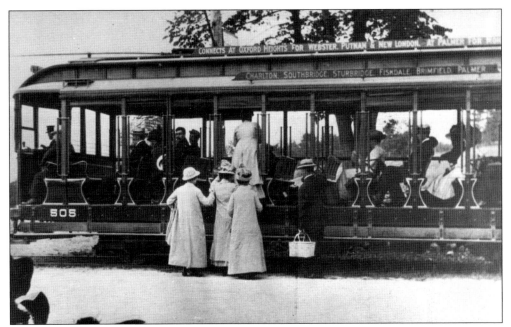

The Springfield trolley of the Worcester & Southbridge Street Railway Company heading east to Worcester is stopped at the Overlook station stop. Carlos Bond, Mrs. Bond, and Mrs. Fellows are getting on at their home opposite the Masonic Home, according to the inscription on the back of the photograph.

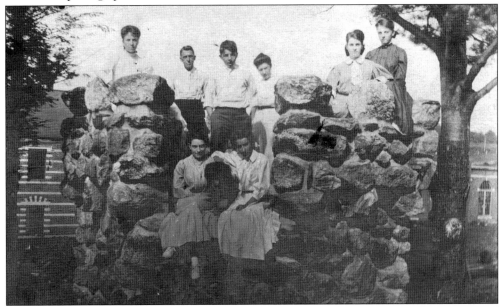

Pineland Park was the name given to the woods next to the Charlton City trolley station and barn on Gillespie Road. The Worcester & Southbridge trolley line had great plans for its Charlton property. Besides the Overlook Hotel, a golf course, and a lake, Pineland Park was to be developed for the trolley patrons. These girls are at the entrance to the park with its monumental gateposts. All of the posts have been removed but one, which remains today on Gillespie Road.

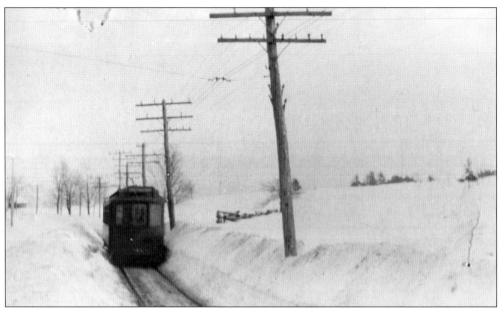

In this 1913 photograph, a Worcester & Southbridge Street Railway trolley car is on the downhill stretch to the Charlton City stop. The Masonic Home waiting station, Overlook, is on the left. This waiting station is the sole remaining rural trolley station in original condition and on the same site in New England. It has recently been restored.

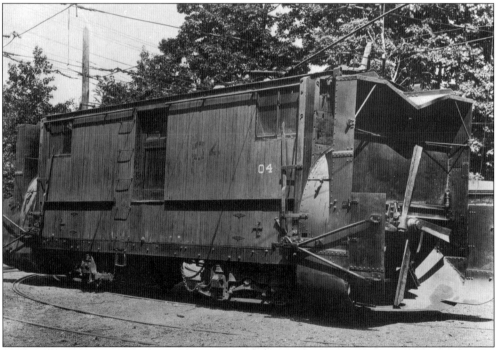

Included in the equipment needed by the Worcester & Southbridge Street Railway, later the Worcester Consolidated Street Railway, was this rotary plow used in severe storms, which drifted snow across the tracks. Several times, storms halted travel on the trolley line until the tracks were cleared using gangs of men with shovels.

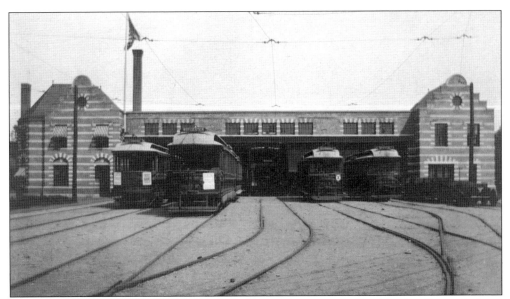

In this photograph, we see a trolley cars of the Worcester & Southbridge Street Railway Company at the Charlton City carbarn. For many years, the trolley companies were anxious to build a line through Charlton. The selectmen refused permission unless a spur line was built to connect to busy Charlton Depot. In 1903, the first trolley car passed through Charlton from Worcester to Southbridge. The carbarn was built as a central service point to service the car of the line. Only a short spur track in the direction of Charlton Depot was ever built.

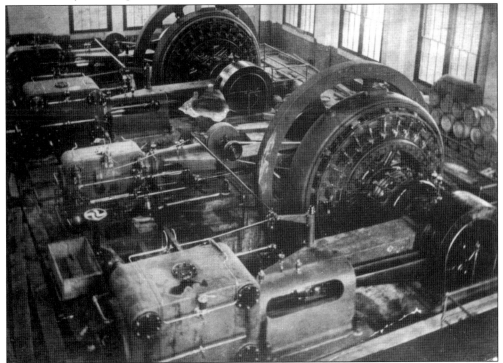

The interior view of the power station of the Worcester & Southbridge Street Railway shows electric generating equipment for the trolley lines in 1903.

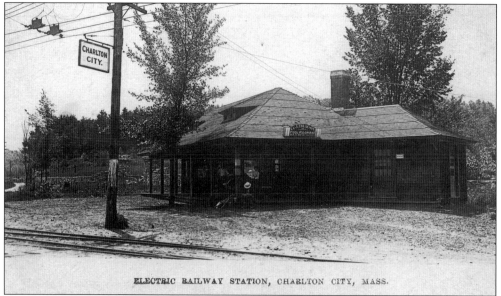

ELECTRIC RAILWAY STATION, CHARLTON CITY, MASS.

The Charlton City waiting station is shown in this view. It was located adjacent to the trolley barn on the corner of Gillespie and Worcester Roads. In the left-hand side was a waiting room and a small spa, which served soft drinks and candies and contained a pool table and other amusements for passengers awaiting the trolley cars. On the right was a barbershop, which was operated by Arthur Dugas and later operated by his son Alfonse until shortly before the building was torn down in the 1960s.

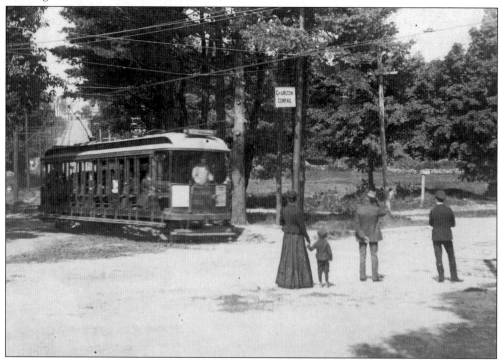

Before M. Daniel Woodbury erected a waiting station at the Charlton Center stop, passengers waited alongside the track. In this 1905 photograph, an open car is headed to Worcester.

110

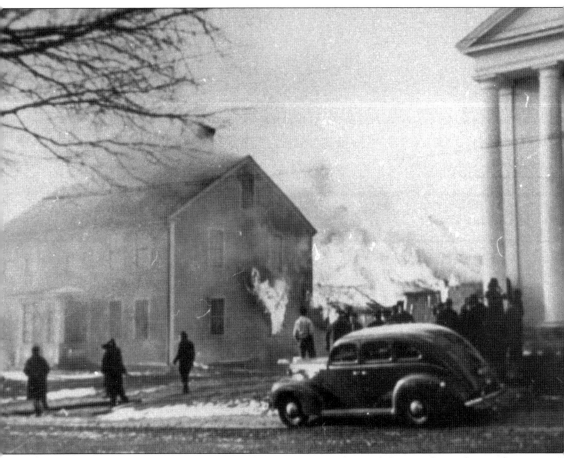

The disastrous fire of December 25, 1939, began in Lewis McIntye's home, shown here. The Federated church next door was subsequently engulfed in flames and reduced to ashes. McIntyre was the local undertaker, and it is said the fire was caused by a kerosene lamp used to thaw water pipes in the basement.

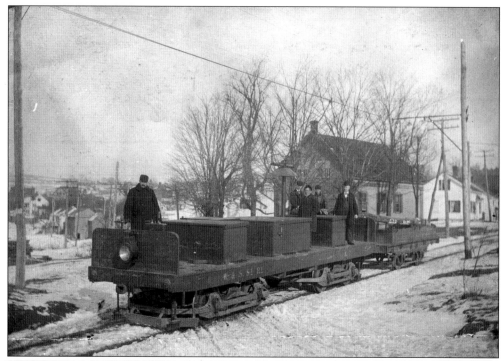

The Worcester & Southbridge Street Railway operated a number of work cars to maintain the lines. Here, we see a work car at Charlton City in 1903.

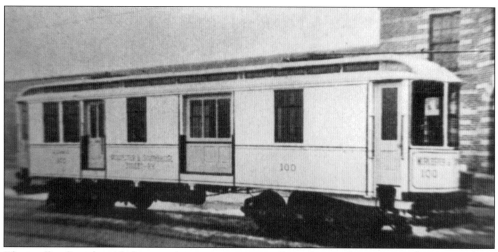

The trolley line provided not only passenger service but also mail service to the towns along the line. This 1904 photograph shows the mail car at the Charlton City station.

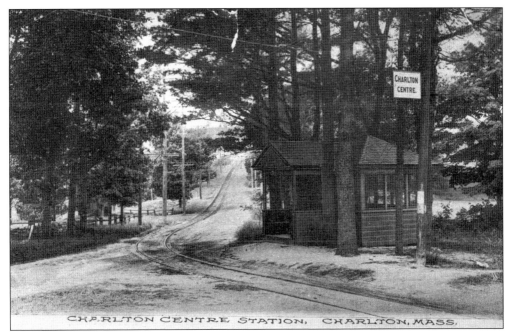

This photograph shows the Charlton Center trolley waiting station. The structure was originally built after the design of M. Daniel Woodbury and sited on the opposite side of Masonic Home Road. After the discontinuation of trolley service in 1928, Woodbury removed the station to his yard on Charlton Common and converted it into a garage, where it remains today.

"Pa" Bracket is shown in 1916 with his horse and wagon in the barnyard at his Sturbridge Road home in Charlton City.

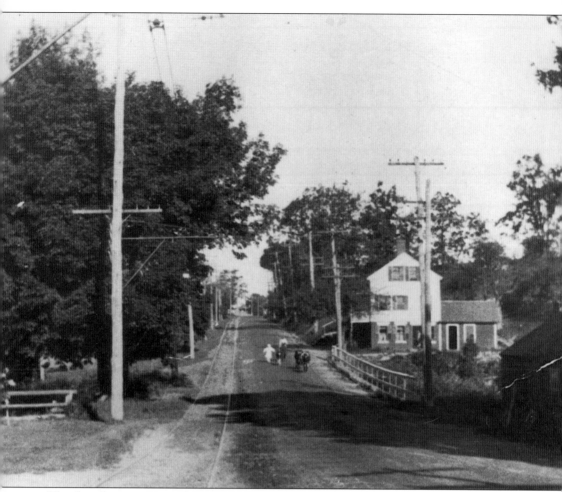

This bucolic scene was taken in 1910 from Bond Square, looking up Masonic Home Road (Route 31). On the right is Deeney's blacksmith shop, occupied today by the Charlton Shopping Center. The Worcester & Southbridge trolley tracks run along the road.

Nine
FAMOUS CHARLTONIANS

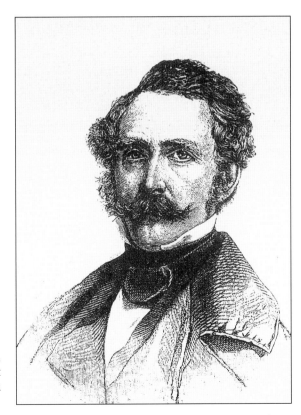

Dr. William Thomas Green Morton, born in Charlton in 1819, was the first to successfully administer ether as an anesthetic in a surgical operation.

Israel Waters acquired this house and property on Cemetery Road before 1780. Waters operated a tannery in the area behind the house. After his death, the house was acquired by Thomas Morton, father of William T.G. Morton. Young Morton became a dentist in Boston, where he conducted experiments with ether as an anesthetic. In 1846, he administered ether successfully in a surgical operation for the first time.

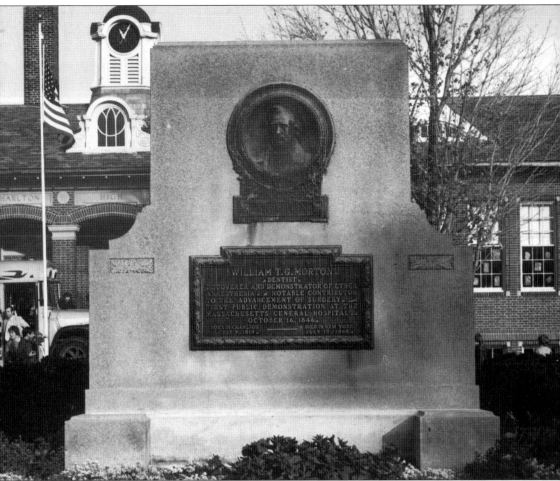

The Dr. William Thomas Green Morton monument is on Charlton Common. Dr. Morton is world-renowned for his demonstration of ether as an anesthetic. It is written on his grave in Mount Auburn cemetery in Cambridge, "William T.G. Morton, inventor and revealer of anesthetic inhalation before whom, in all time, surgery was agony. By whom, pain in surgery was averted and annulled, since whom science has control of pain."

Julia H. Gould, 82 years old, unveiled the monument at the Morton Memorial on Charlton Common on September 1, 1921. Gould was a relation to Dr. Morton.

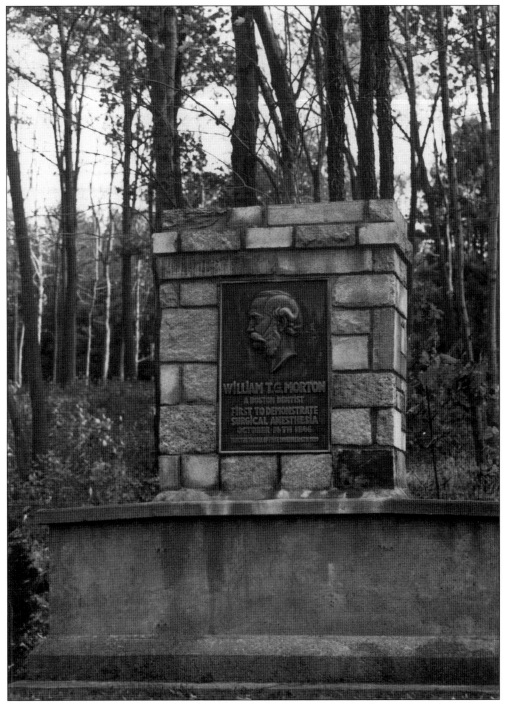

Morton Memorial was presented to the town of Charlton in 1946 by the centennial committee of the Massachusetts Dental Society and is located on Worcester Road. It was moved and reerected by Bruce Lamprey with support of the American Society of Anestheologists and its Massachusetts branch and the World Library Museum in 1987. Road construction adjacent to it in 2001 has required that the monument be moved again.

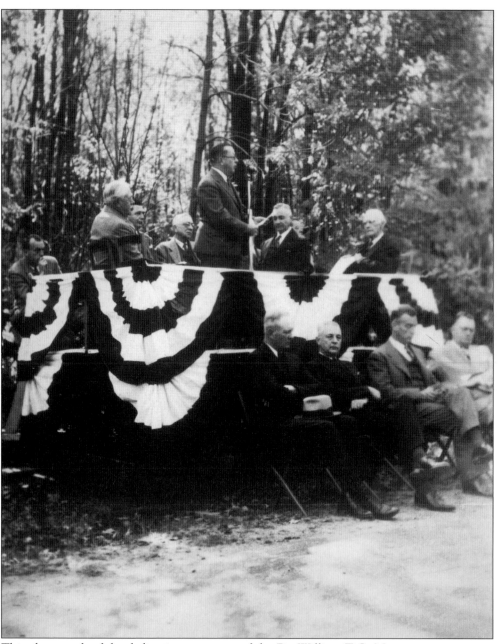

This photograph of the dedication ceremony of the Dr. William T.G. Morton monument on Worcester Road (Route 20) was taken by a local photographer. Dr. Morton, perhaps Charlton's most famous son, is honored by four memorials to his greatest accomplishment: the banishing of pain from the operating table. This monument was dedicated by the Morton Centennial Committee on the occasion of Dr. Morton's 100th birthday on October 15, 1946. Dr. Kurt H. Thoma, national chairman of the Morton Centennial Committee, is shown here addressing the gathering.

The annual Old Home Day celebration is a weekend of attractions for Charltonians and thousands of visitors. The 1911 parade featured an assembly of decorated automobiles. In the photograph, John Hammond's Buick is driven by his daughter Anna the first licensed female driver in Charlton. Seated beside Hammond is Mildred Tucker. In the rear seat are Henrietta Waldon and Dorothy Woodbury.

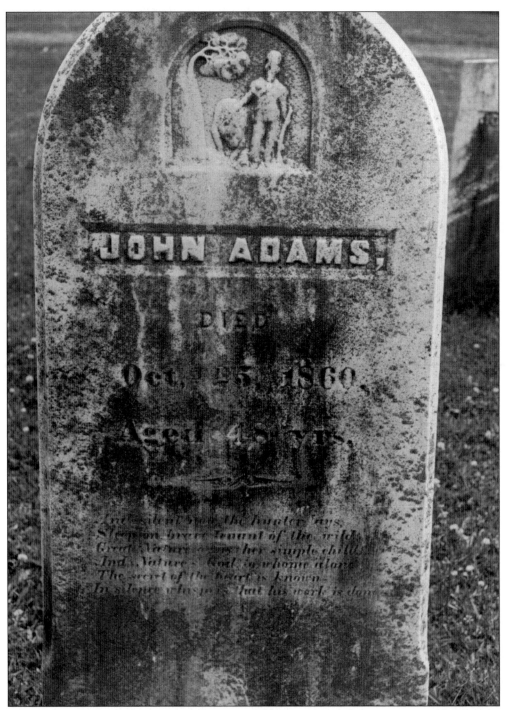

John Capen Adams ("Grizzly Adams") is one of Charlton's most famous attractions. His grave is located in the old Bay Path Cemetery. He is buried with his parents and other family members. After several years in the wild of the western mountains, Adams opened a Wild West show featuring his "tamed" wild animals. This drew the attention of P.T. Barnum, who featured Adams in his show. Grizzly Adams died after a severe mauling by one of his bears in 1860.

This is a photograph of John P. Marble, proprietor of the store at Charlton Northside and, at one time, owner of the Rider Tavern. Later, he was a manufacturer and businessman in Worcester.

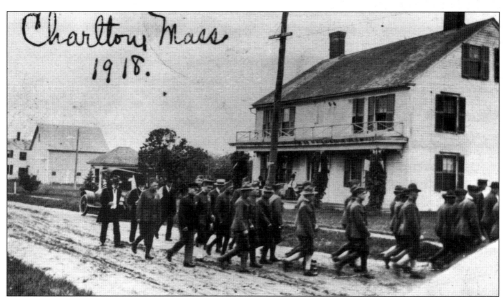

Old Home Day is always celebrated on Labor Day. This 1918 Old Home Day Parade honored the World War I soldiers. Russell Warren and Warren Tucker are the two Marines near the rear of the group. Capt. William King, a Civil War veteran, takes up the rear. The photograph was taken in front of the Weld Tavern, at 44 Main Street in Charlton Center.

The Wakefield houses on Carroll Hill Road, Dodge Village, are shown in this 1900 picture. The house in the distance is the birthplace of Dr. Martin Rutter, D.D., early Methodist circuit rider, author, educator, missionary, and bishop. Born here in 1785 to a local miller, Rutter later became the youngest licensed preacher in the Methodist Church at age 15. The house was extremely renovated in 1947 to its present appearance. The nearer house was taken down in a dilapidated state in 1950.

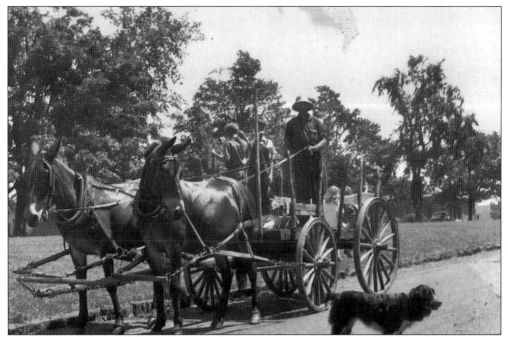

John Stevens, with his pair of mules, poses for the camera at Charlton Center in 1949. Stevens, who lived on Schoolhouse No. 6 Road, did the contract haying for Ernest Blood at Charlton Center. Stevens preferred mules to horses; he was perhaps the only farmer in Charlton to use mules exclusively for his farm work.

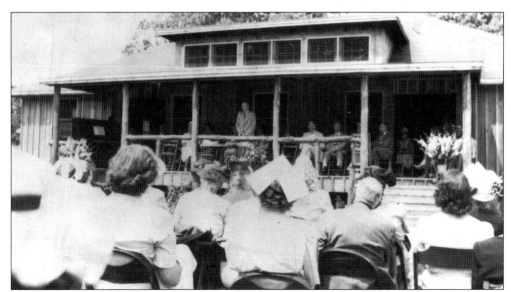

Dr. Elliott P. Joslin, renowned physician specializing with diabetes, speaks at the dedication of the Joslin Diabetic Camp at its 1948 opening. The first group of diabetic boys opened the camp that summer. It is now paired with the Clara Barton Camp for Diabetic Girls in nearby Oxford.

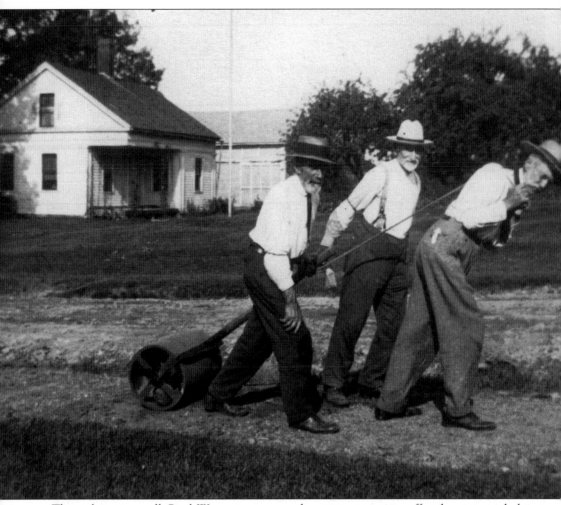

These three men, all Civil War veterans, are showing community effort by giving a helping hand in the construction of the first sidewalks through Charlton Center in 1918. They are, from left to right, Sgt. Thomas Rodgers, age 70; Capt. William King, age 82; and Rev. Edgar Preble, age 76.

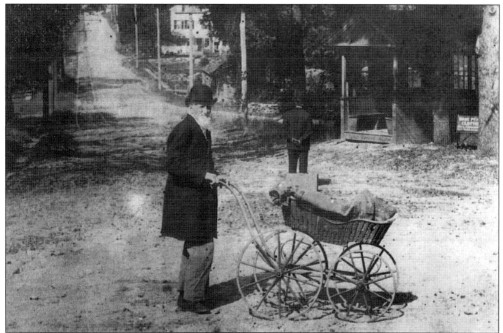

George Bartlett, known as "Uncle Sam," is shown with the baby carriage in which he carried mail from the trolley stop in Charlton Center to the post office on Charlton Common. Postmaster M. Daniel Woodbury engaged Bartlett to bring the twice-daily mail delivered to Charlton on the trolley cars. Bartlett was the only mail carrier from 1903 until illness caused him to give up the job in 1908. A year later, he died at the Charlton Town Farm. The Charlton Center trolley station at Bond Square can be seen across from the man awaiting the eastbound car.

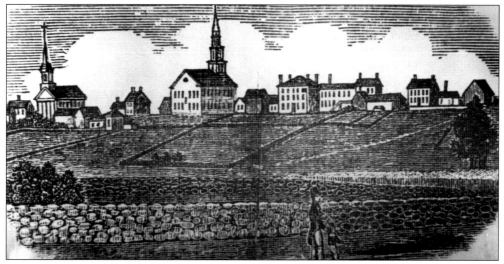

Here is a view of Charlton Center from the John Warner Barber book *Barber's Historical Collection* in 1841. This northeast view shows, from left to right, the Calvinistic Congregational Church, burned in 1939; the Universalist church, burned in 1922; the three-story Belleview House, burned in 1888; and the T.D. Moore house, built in 1826 and still standing.

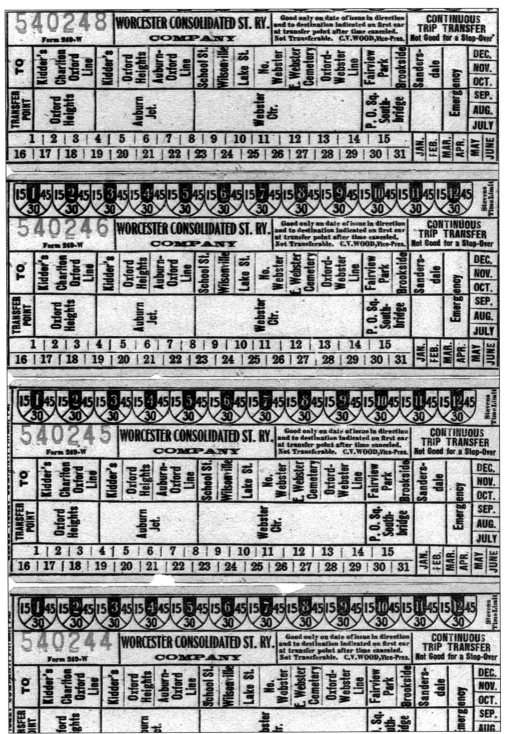

Pictured are trolley fare tickets of the Worcester Consolidated Street Railway, successor to the Worcester & Southbridge Street Railway, which ran trolleys through Charlton until 1928. Buses replaced trolleys until public transportation was suspended in the early 1970s.